THE BEST OF
WATERCOLOR

Compiled by Betty Lou Schlemm and Tom Nicholas

ROCKPORT
PUBLISHERS

ROCKPORT PUBLISHERS ROCKPORT, MASSACHUSETTS

DISTRIBUTED BY NORTH LIGHT BOOKS CINCINNATI, OHIO

FIRST PUBLISHED IN THE UNITED STATES OF AMERICA BY:
ROCKPORT PUBLISHERS, INC.
146 GRANITE STREET
ROCKPORT, MASSACHUSETTS 01966-1299
TELEPHONE: (508) 546-9590
FAX: (508) 546-7141

DISTRIBUTED TO THE BOOK TRADE AND ART TRADE IN THE U.S.
BY:
NORTH LIGHT, AN IMPRINT OF
F & W PUBLICATIONS
1507 DANA AVENUE
CINCINNATI, OHIO 45207
TELEPHONE: (513) 531-2222

OTHER DISTRIBUTION BY:
ROCKPORT PUBLISHERS, INC.
ROCKPORT, MASSACHUSETTS 01966

ISBN 1-56496-207-5

10 9 8 7 6 5 4 3 2 1

ART DIRECTOR: LAURA P. HERRMANN
ACQUISITIONS EDITOR: ROSALIE GRATTAROTI
DESIGN FIRM: C. A. BUCHANAN DESIGN
COVER PAINTING: (FRONT) DONG KINGMAN
 (BACK) SHERRY SILVERS

PRINTED IN SINGAPORE

ACKNOWLEDGEMENTS

It was great to be asked

to help with this book—

what a show we saw!

Thank you all.

Betty Lou Schlemm, A.W.S., D.F.

As I write this, it could only have happened in the Arabian Nights. In 1959, I was the second vice president of the American Watercolor Society when I was asked by my friend Chen Chi to run for president. Of course I was delighted! But the delight did not last long. I found that we were bankrupt, and, in addition, that we were not tax-exempt—or even

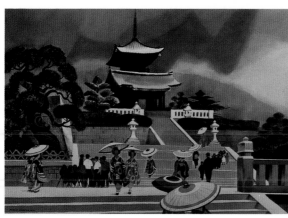

incorporated. We were faced with a manager whose salary had to be paid with our current and next year's dues.

Luckily, I was then teaching watercolor and some of my students knew "persons in high places." Also, I had some dear friends from my active days in the Society of Illustrators. One of them, Lincoln Levine, was a corporation lawyer who came to our aid. In no time, we were tax-exempt and had become a corporation. I got my students involved in the Society, serving as directors and chairmen. The women became officers during my administration—they served brilliantly—and Dale Meyers is now president. I got rid of "purchase awards" (monetary awards that buy works away from the artist who created them) and started a program of medals.

Our awards became famous, and we established the Dolphin Fellowship. I swore that our society would never go begging for awards again. My administration ended in 1986, and after 27 years I was proud to have left the Society with more than half a million dollars in the black.

—Mario Cooper, N.A., P.P.A.W.S., D.M., D.F., President Emeritus

And the show began...
Wonderful...

Just four thousand five hundred paintings before us. What was to be a day of jurying became two days, and then a few more hours. Over and over we reviewed the slides and transparencies, choosing those of excellence, and enjoyed all the hours of seeing some of the finest watercolors done in America. There were far too many great paintings, and with dismay we had to start eliminating many truly good pieces—because of sameness of subject matter, similar style, and, sometimes, perhaps because of a far off reason that is hard to pinpoint. We had to think of the book. A book that would encompass all the styles and thoughts of American art today, a book of great variety.

We saw so many prize paintings from exhibitions all over the country. Not even knowing these artists personally, we felt we had met friends again because of their work.

Tom Nicholas was the other "juror" of this book, a friend for more than thirty years, a member of the National Academy, a member of the American Watercolor Society, and of many other watercolor associations. Little by little, remembrances were brought up, of the impressive painters we were seeing now and of those great painters we have known over the years.

We thought of Mario Cooper, the president of the American Watercolor Society for twenty-seven years, and now president emeritus. It is hard to think of watercolor today—American watercolor—without first thinking of this great man who added so much to the growth and fine tradition of our medium, watercolor as we know it today. How fitting to dedicate the first volume of **THE BEST OF WATERCOLOR** *to Mario Cooper, National Academy, American Watercolor Society.*

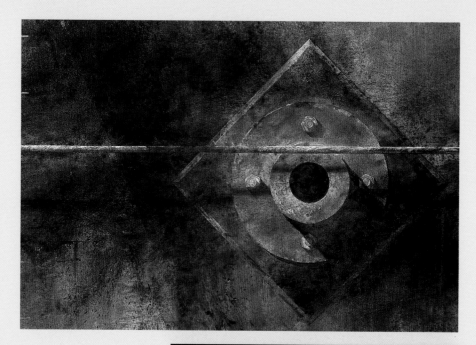

LARRY WEBSTER
CABLE, FLANGE, AND
SCALE
39" x 27" (99.1 cm x 68.6 cm)
Fabriano Artistico 100 lb.

M.C. KANOUSE
SISTER MAURA'S
CHICKENS II
13.5" x 21" (34.3 cm x 53.3)
Lana Aquarelle 300 lb. cold press

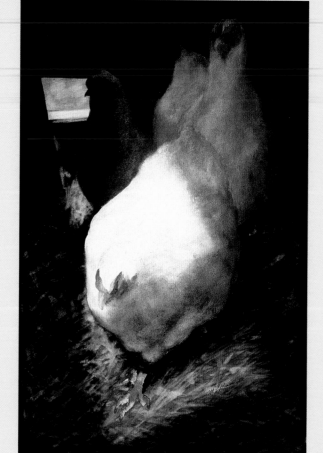

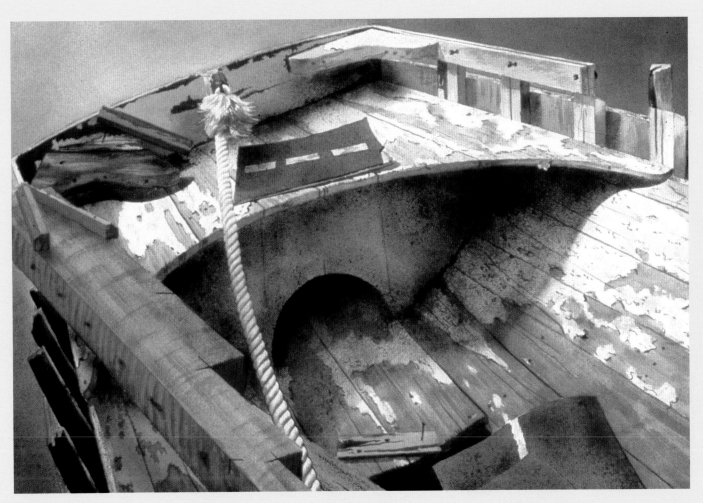

JOHN BRYANS

NEEDS WORK

29.5" x 41" (74.9 cm x 104.1 cm)

Arches 140 lb. rough

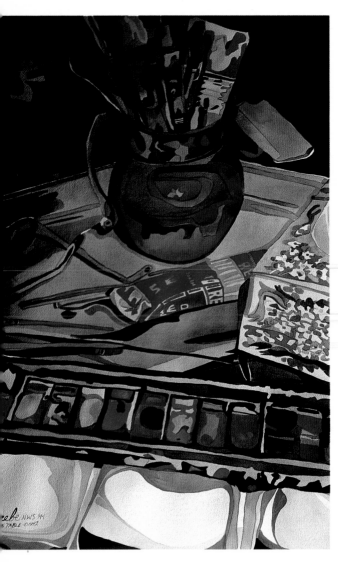

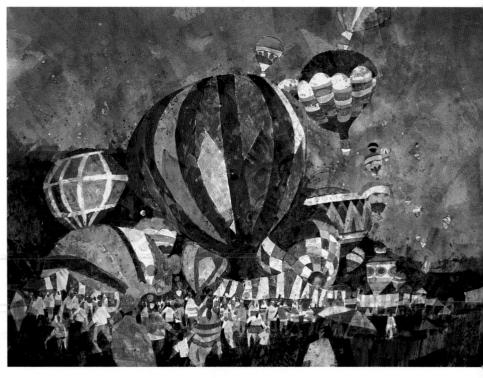

ARNE LINDMARK, N.A., A.W.S., D.F.
LIFT OFF AT DAWN
22" x 30" (55.9 cm x 76.2 cm)
Fabriano Artistico 140 lb. rough
Media: Water based acrylic, watercolor glazes

SANDRA E. BEEBE,
A.W.S., N.W.S.
TOM'S TABLE
30" x 22" (76.2 cm x 55.9 cm)
Arches 140 lb. cold press

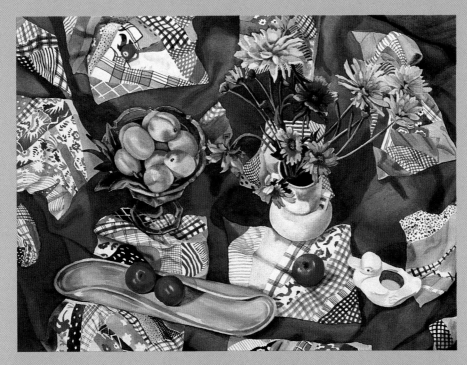

MAXINE YOST

STILL ON CRAZY QUILT

22" x 30" (55.9 cm x 76.2 cm)

Arches 300 lb.

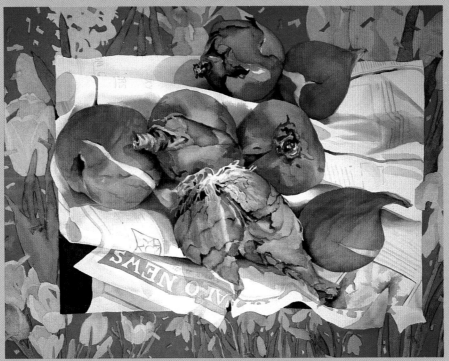

SUSAN WEBB TREGAY

THEY'RE NOT ONIONS

22" x 30" (55.9 cm x 76.2 cm)

Arches 140 lb. cold press

**PEGGY BROWN,
A.W.S.. N.W.S.**

DUET

26" x 40" (66 cm x 101.6 cm)

Rives lightweight

Media: Transparent watercolor,
graphite, collage

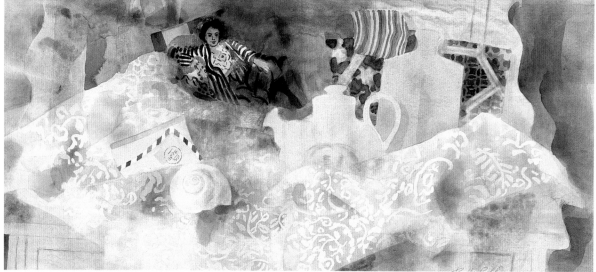

RUTH COBB

HOMAGE TO MATISSE

18.5" x 39" (47 cm x 99 cm)

Whatman 133 lb. hot press

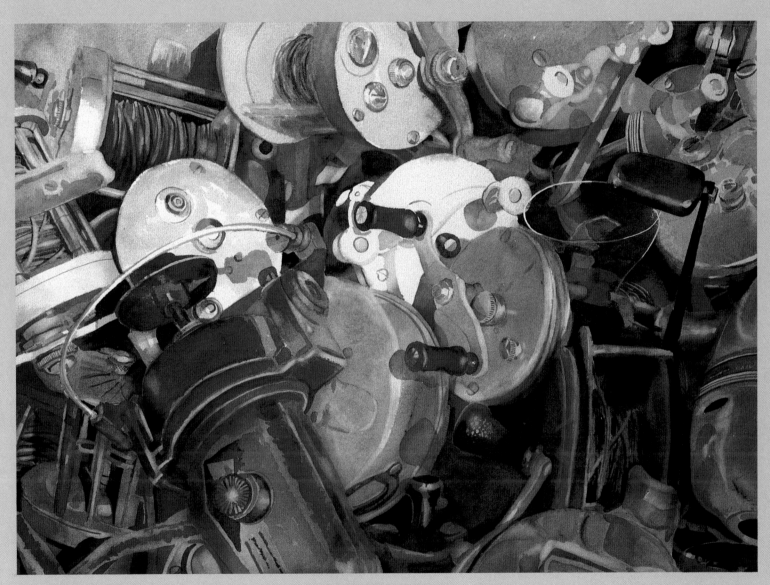

DICK GREEN, M.W.S.

REEL UPON REEL

22" x 30" (55.9 cm x 76.2 cm)

Arches 300 lb. cold press

RENEÇ FAURE

FAMILY PORTRAIT

29.5" x 41.5" (74.9 cm x 105.4 cm)

Arches 300 lb.

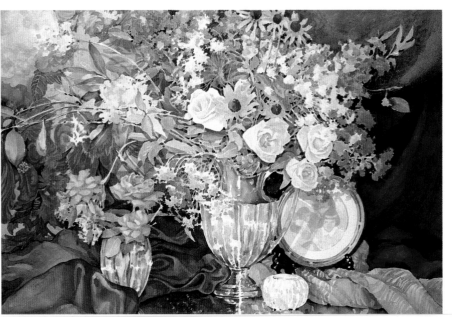

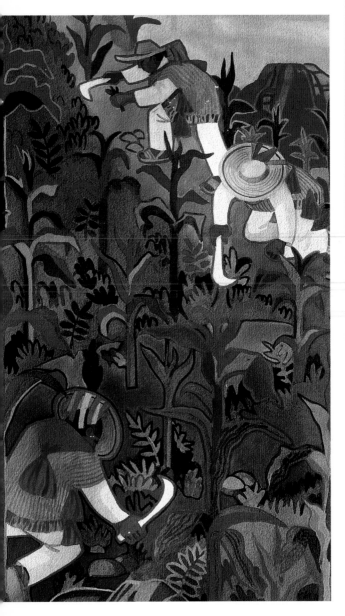

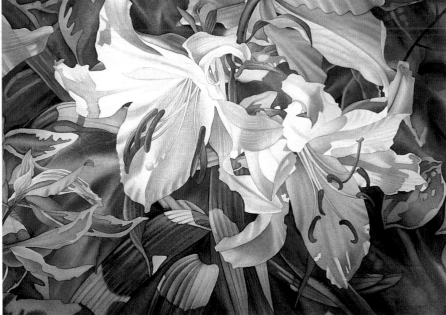

JOANNA MERSEREAU

TAPESTRY OF CORN

30" x 22" (76.2 cm x 55.9 cm)

Arches 300 lb. cold press

NANCY MEADOWS TAYLOR, N.W.S.

RAPSODY IN BLUE II

29" x 41" (73.7 cm x 104.1 cm)

Arches cold press

Media: Transparent pigments, occasional gouache

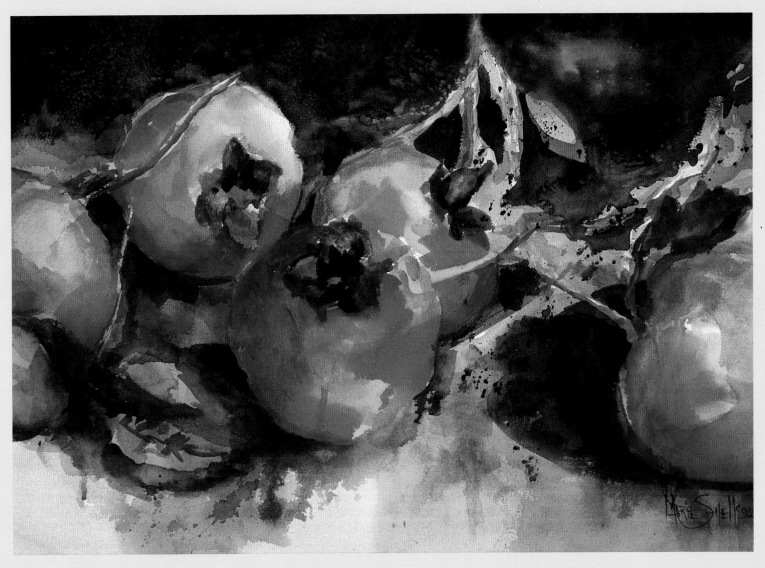

MARIE SHELL

AUTUMN TREASURE

22" x 30" (55.9 cm x 76.2 cm)

Arches 300 lb. rough

JACK JONES

TRINITY CHURCH

21" x 29" (53.3 cm x 73.7 cm)

Arches 140 lb. cold press

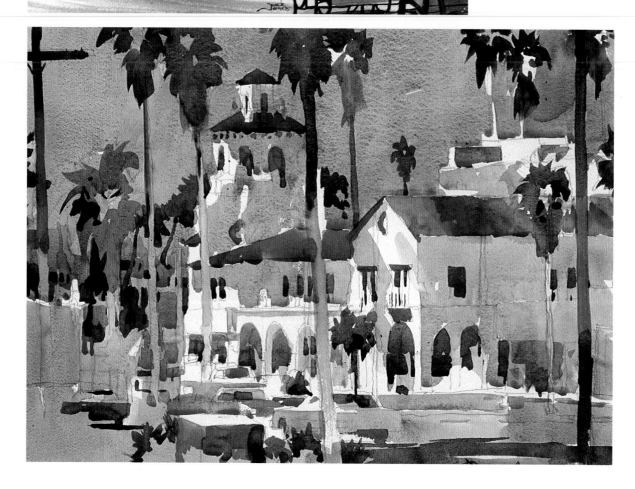

DON O'NEILL, A.W.S.

OLD FOX THEATER

20" x 28" (50.8 cm x 71.1 cm)

Bockingford 140 lb. cold press

GEORGE KOUNTOUPIS

GRANADA AT NIGHT

22" x 30" (55.9 cm x 76.2 cm)

Arches 300 lb. cold press

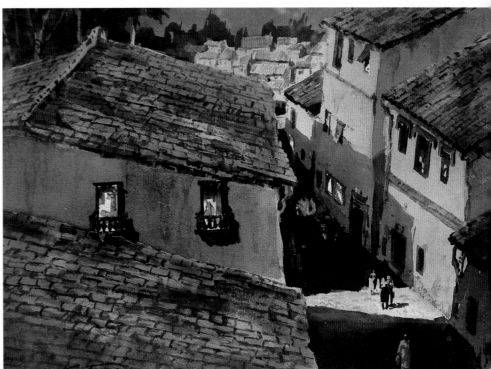

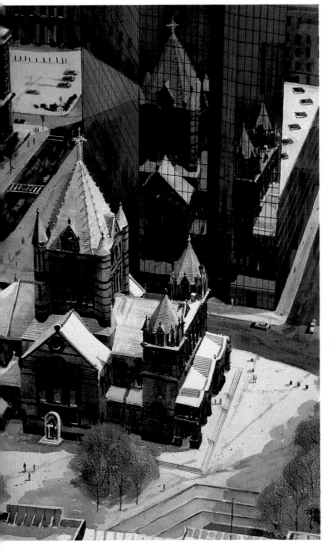

FREDERICK KUBITZ, A.W.S.

BIRD'S EYE VIEW TRINITY CHURCH - WINTER

22" x 30" (55.9 cm x 76.2 cm)

Arches 300 lb. cold press

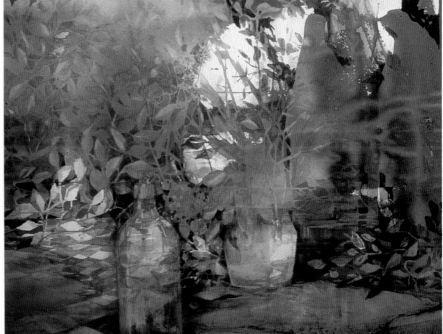

BETTY LYNCH, A.W.S.

BACKLIGHT

21" x 29" (53.3 cm x 73.7 cm)

Arches 140 lb. cold press

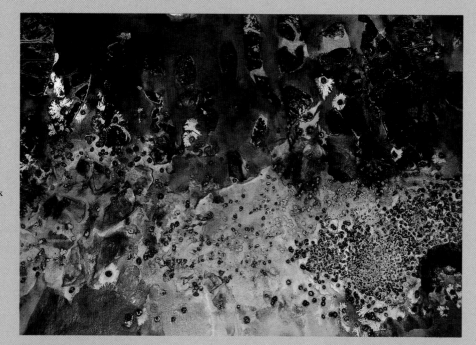

JEAN MUNRO

THINGS THAT GO BUMP
IN THE NIGHT
26" x 34" (66 cm x 86.4 cm)
Arches 140 lb. cold press
Media: Ink, shapes in plastic, rock
salt

ASTRID E. JOHNSON,
N.W.S.

COLORADO RIVER
22" x 30" (55.9 cm x 76.2 cm)
Arches 140 lb.

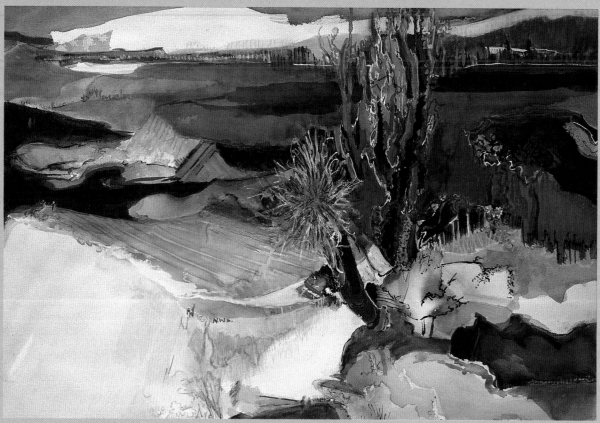

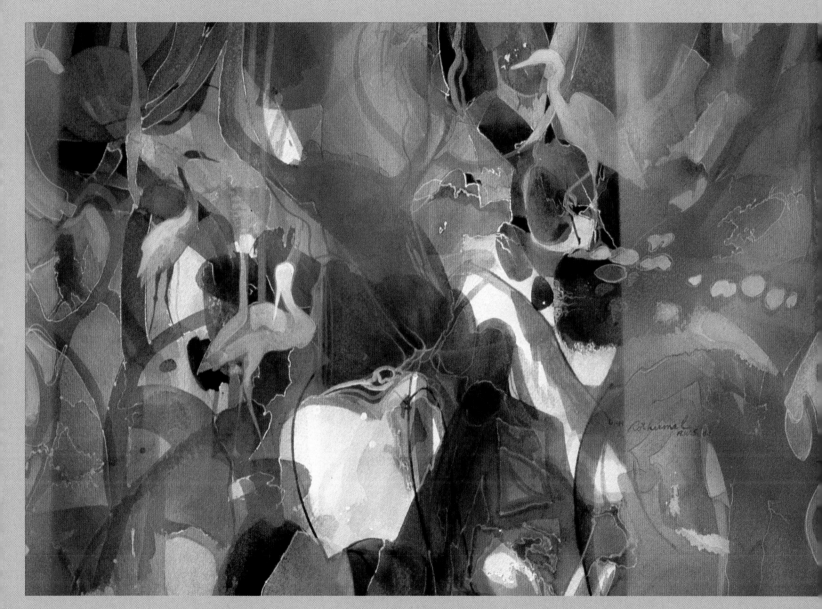

JOAN ASHLEY ROTHERMEL, A.W.S.

HERON HAVEN

12" x 18" (30.5 cm x 45.7 cm)

Arches 140 lb.

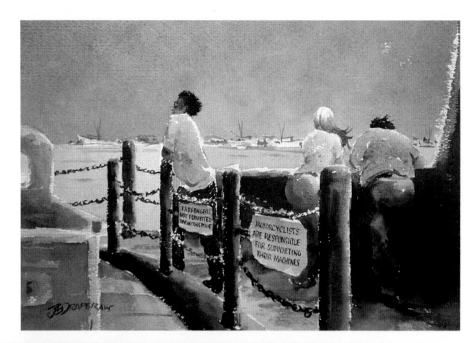

**J. EVERETT DRAPER,
A.W.S.**

MAYPORT FERRY I

10" x 14" (25.4 cm x 36.6 cm)

Arches 140 lb. rough

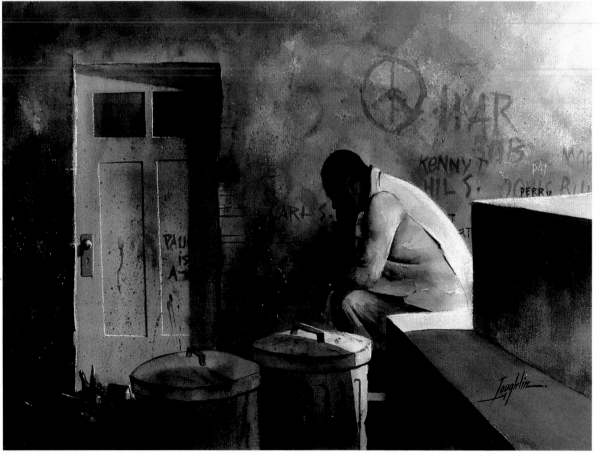

JOHN L. LOUGHLIN

GHETTO THINKER

22" x 30" (55.9 cm x 76.2 cm)

Arches 300 lb. cold press

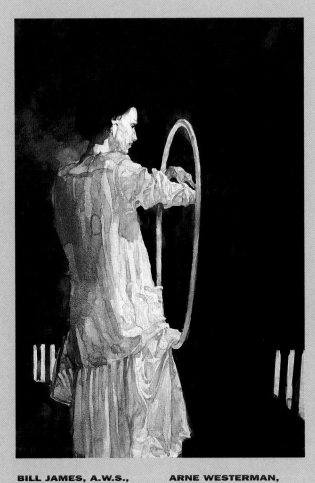

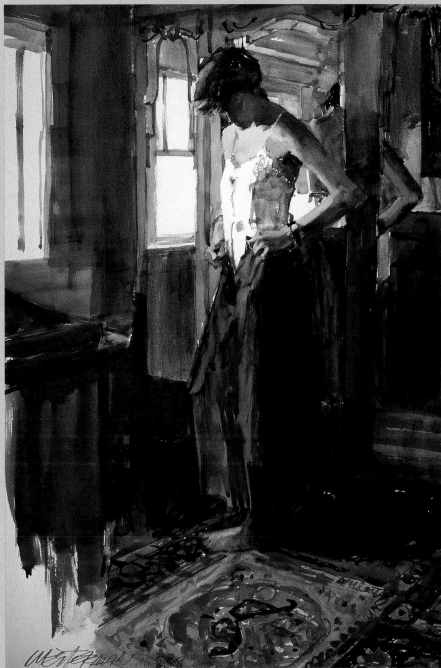

**BILL JAMES, A.W.S.,
P.S.A.**

MANNEQUIN WITH HOOP
33" x 26" (83.8 cm x 66 cm)
Crescent
Media: Gouache

**ARNE WESTERMAN,
A.W.S., N.W.S.**

CAROL WITH ANTIQUE
WARDROBE
37" x 25" (92.5 cm x 62.5 cm)
Lana Aquarelle 140 lb. hot press

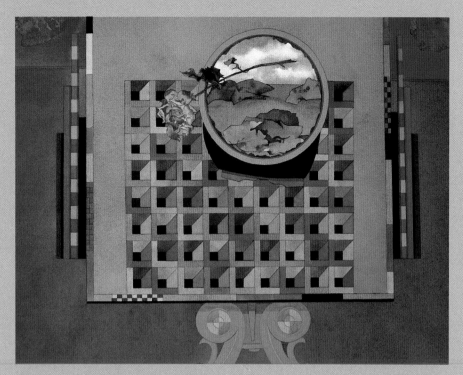

EDWARD REEP
HOW DID YOU KNOW I
NEEDED A ROSE
28" x 38" (71.1 cm x 96.5 cm)
Arches 140 lb. rough

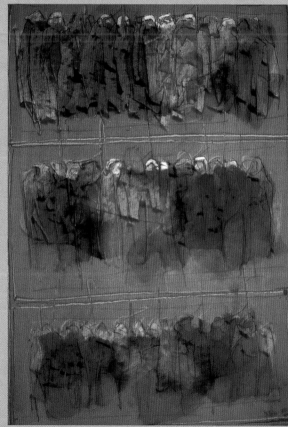

JOHN McIVER, A.W.S,
N.W.S., W.H.S.
PARADE IV
35" x 25" (89 cm x 63 cm)
Arches 260 lb. cold press, single
elephant
Media: Acrylic wash, carbon line

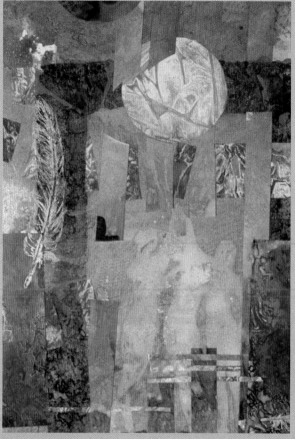

KATHLEEN BARNES
MOONDANCE
15" x 20" (38.1 cm x 50.8 cm)
Strathmore Aquarius 90 lb.

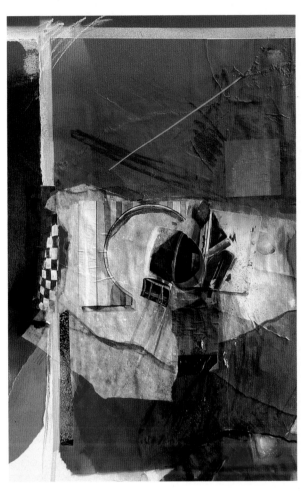

**J. LURAY SCHAFFNER,
N.W.S.**

COLOR, CHAIN AND RED

40" x 30" (101.6 cm x 76.2 cm)

4-ply museum board

Media: Watercolor collage

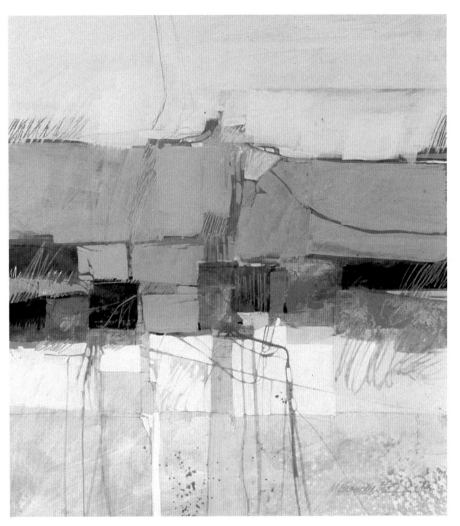

AL BROUILLETTE

HORIZONS III

20" x 18" (50.8 cm x 45.7 cm)

Strathmore 500 board

Media: Transparent acrylic, semi-
opaque and opaque watercolor

FRED L. MESSERSMITH,
A.W.S., W.H.S.
MAINE MOODS
22" x 30" (55.9 cm x 76.2 cm)
Arches 300 lb. cold press
Media: Watercolor, gouache

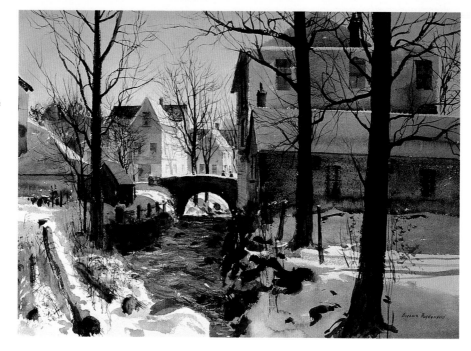

BOGOMIR BOGDANOVIC
WHISPERING BROOK
22" x 28" (55.9 cm x 71.1 cm)
Arches 140 lb. cold press

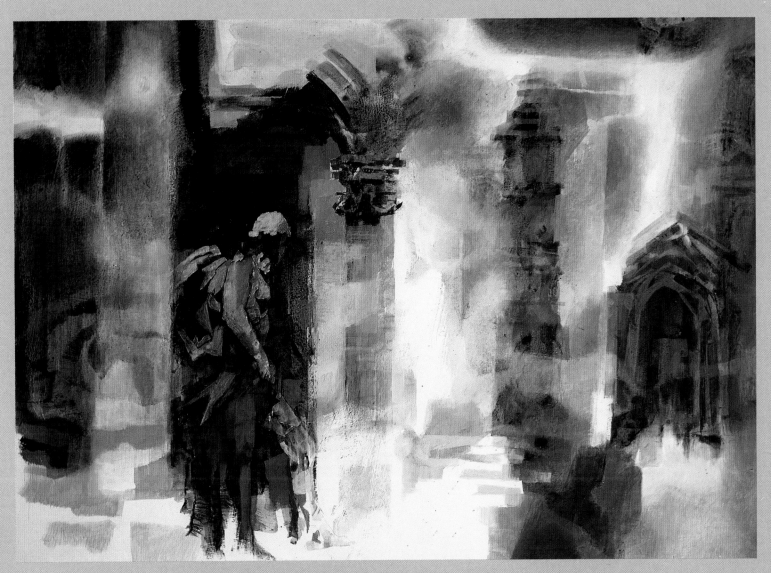

CAROL PYLE JONES, N.A., A.W.S., D.F.

TEMPLE OF APOLLO

60" x 32" (152.4 cm x 81.3 cm)

Illustration board

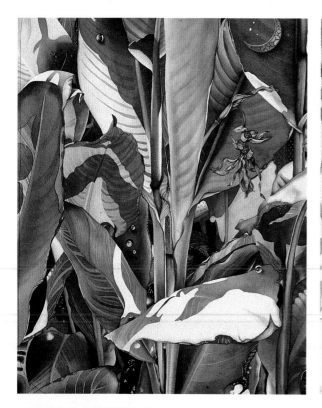

SABINE M. BARNARD, N.W.S.

SUMMER FOREST

22" x 30" (55.9 cm x 76.2 cm)

Arches 300 lb. cold press

Media: Metallic watercolor

JEAN H. GRASTORF, A.W.S., N.W.S.

SUN-KISSED

20" x 28" (50.8 cm x 71.1 cm)

Waterford 300 lb. rough

ANN PEMBER

MAGNOLIA

14" x 21" (35.6 cm x 53.3 cm)

Arches 140 lb. cold press

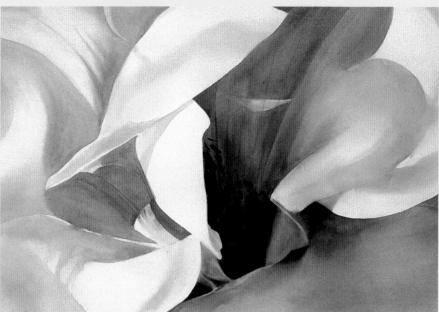

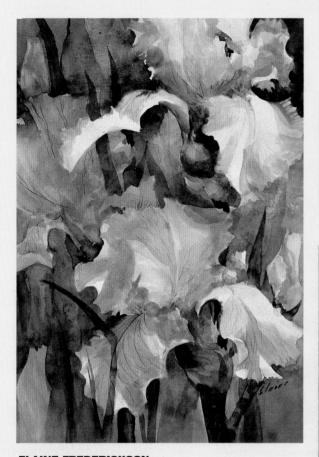

ELAINE FREDERICKSON

WHITE IRISES

22" x 30" (55.9 cm x 76.2 cm)

Whatman 140 lb. cold press

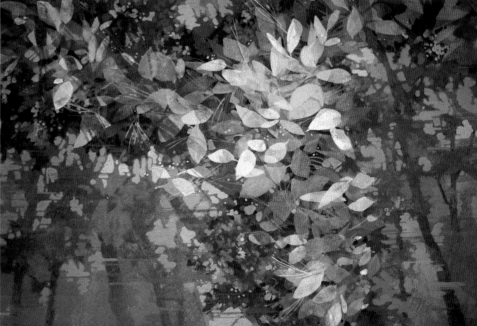

CYNTHIA L. WILSON

WINDSWEPT

15" x 22" (38.1 cm x 55.6 cm)

Arches 140 lb. cold press

Media: 100% acrylic layered washes

CELIA CLARK

ANNA

21.5" x 21.5" (54.6 cm x 54.6 cm)

Arches 140 lb. cold press

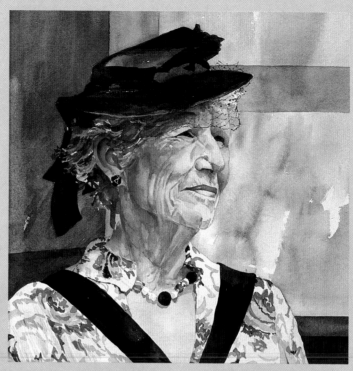

**LINDA J. CHAPMAN
TURNER, W.V.W.S.,
M.W.S.**

THE BLUE VASE

14" x 10" (35.6 cm x 24.4 cm)

Arches 300 lb. cold press

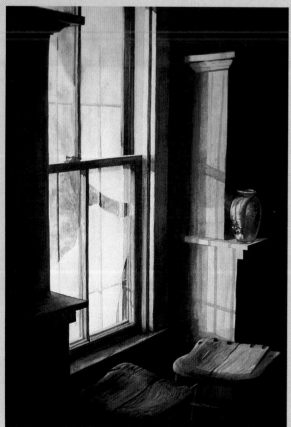

**CAROLYN GROSSÉ
GAWARECKI**

SUNCAST

29" x 21" (73.7 cm x 53.3 cm)

Arches 140 lb. rough

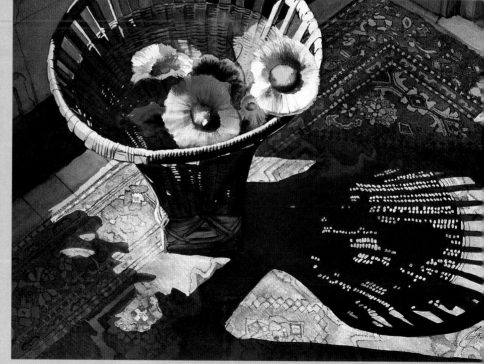

JANET SWANSON

1 - 2 - 3 - GO

28" x 36" (71.1 cm x 91.4 cm)

Arches 140 lb. cold press

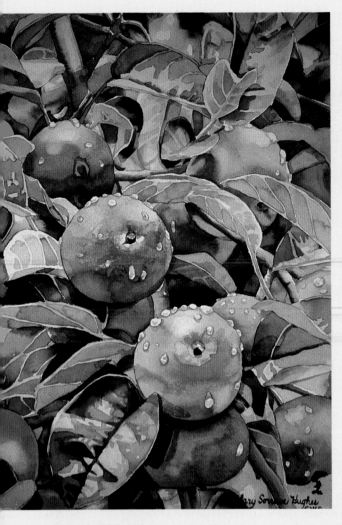

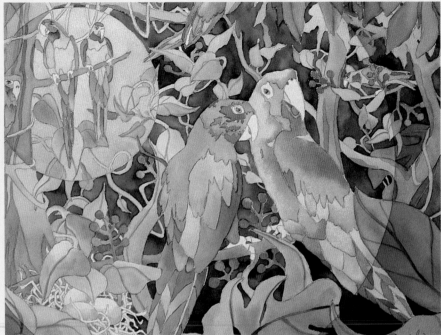

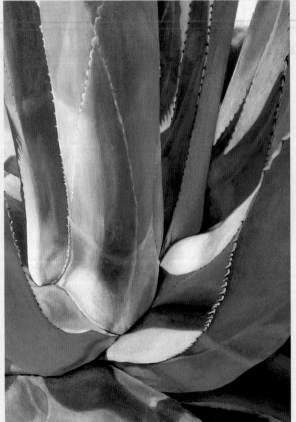

MICKEY DANIELS
MOONLIGHT SERENADE
14" x 20" (35.6 cm x 53.3 cm)
Arches 140 lb. cold press

MARY SORROWS
HUGHES
STRAWBERRY BANKE
APPEAL
15" x 21" (38.1 cm x 53.3 cm)
Arches 140 lb. cold press

NEDRA TORNAY, N.W.S.
AGAVE CACTUS
30" x 22" (76.2 cm x 55.9 cm)
Waterford 300 lb. rough

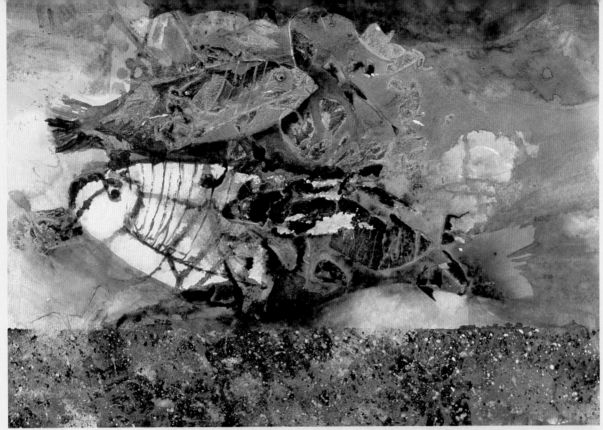

DONNA SHUFORD

FOSSILS

28" x 36" (71.1 cm x 91.4 cm)

Morilla

Media: Watercolor collage

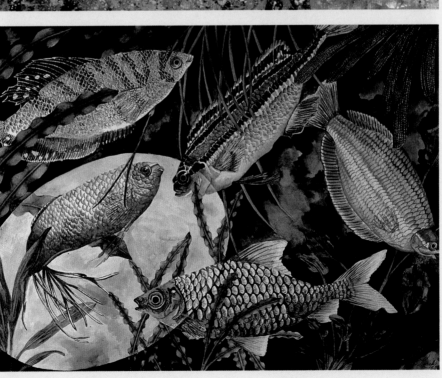

FRANCES KIRSH, F.W.S.

FISHES IN GRAY & YELLOW

15" x 20" (38.1 cm x 50.8 cm)

Crescent smooth

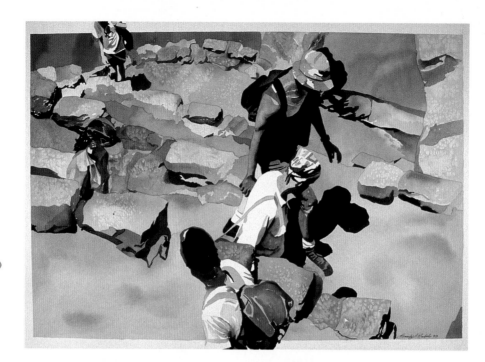

BEVERLY NICHOLS

LABYRINTH OF THE
MINOTAUR

29.5" x 41" (74.9 cm x 104.1 cm)

Arches 555 lb. cold press

ROBERT G. SAKSON,
A.W.S., D.F.

LOCOMOTIVE

22" x 30" (55.9 cm x 76.2 cm)

Arches 140 lb. rough

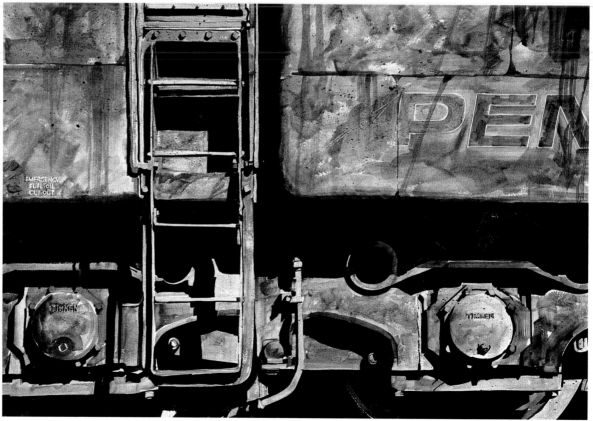

DORIS O. TURNBAUGH

ANTIQUE SHOPPE

24" x 30" (60.9 cm x 76.2 cm)

Arches 140 lb. cold press

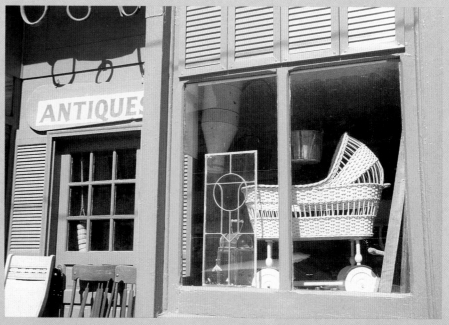

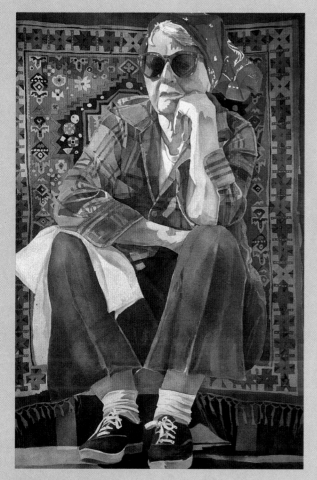

**BONNIE PRICE, A.W.S.,
N.W.S.**

LOIS

22" x 30" (55.9 cm x 76.2 cm)

Arches 140 lb. hot press

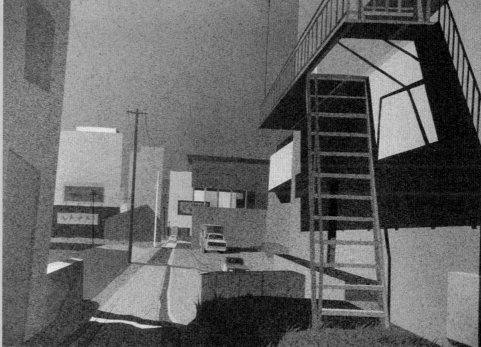

MARK E. MEHAFFEY

SOUTHERN EXPOSURE II

22" x 30" (55.9 cm x 76.2 cm)

Arches 140 lb. hot press

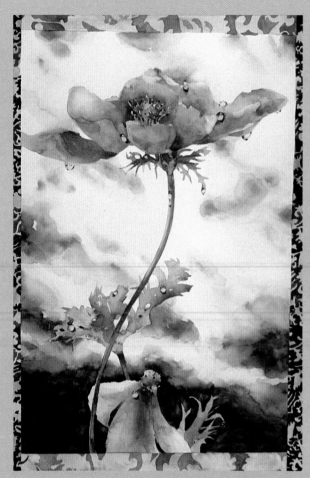

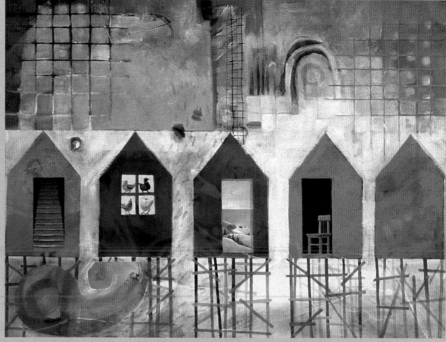

MICHAEL SCHLICTING
LIFE'S CHOICES
22" x 30" (55.9 cm x 76.2 cm)
Arches 300 lb. cold press
Media: Transparent watercolor underpainting, gouache

SHARON HILDEBRAND
ANEMONE
33" x 25" (83.8 cm x 63.5 cm)
Fabriano Classico 280 lb. cold
press

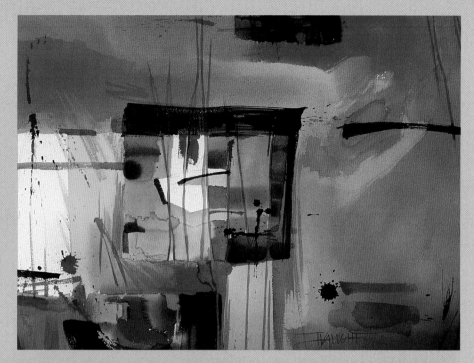

TED VAUGHT
ON THE WARPATH
21" x 29" (53.3 cm x 74.7 cm)
Arches 140 lb. rough

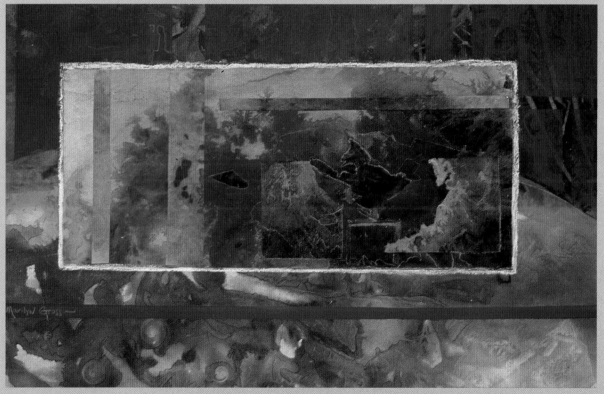

MARILYN GROSS
LIFE FORMS
15" x 21" (38.1 cm x 53.3 cm)
Arches 140 lb. cold press
Media: Watercolor, light fast inks,
quilling paper

MARY BLACKEY
MORNING AND
INDUSTRY
22" x 30" (55.9 cm x 76.2 cm)
Arches 300 lb. cold press
Media: watercolor background,
acrylic for small washes and
details

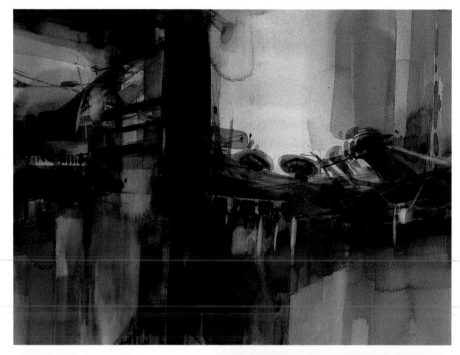

CARLTON B. PLUMMER
VERMONT MILL
21" x 28" (53.3 cm x 71.1 cm)
Arches 140 lb. cold press
Media: Transparent watercolor,
gouache

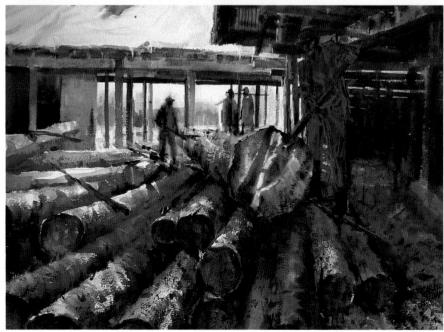

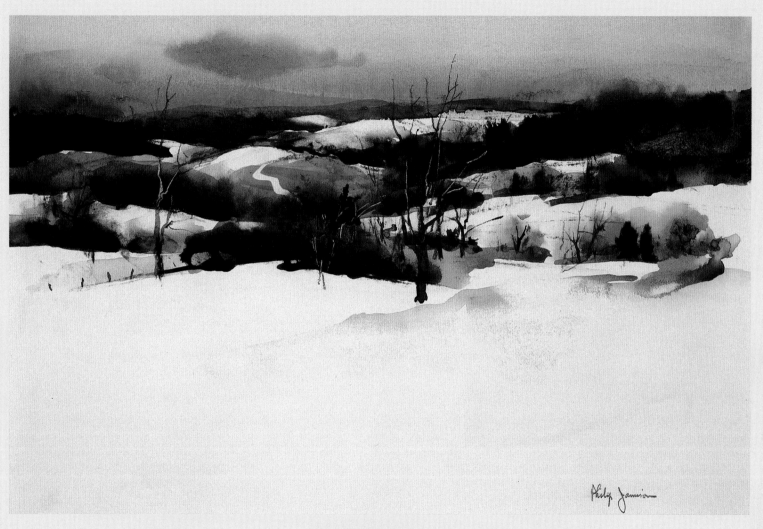

PHILIP JAMISON

HORSESHOE HILLS

9.5" x 14.5" (24.1 cm x 36.8 cm)

Cold press

Media: Watercolor, charcoal

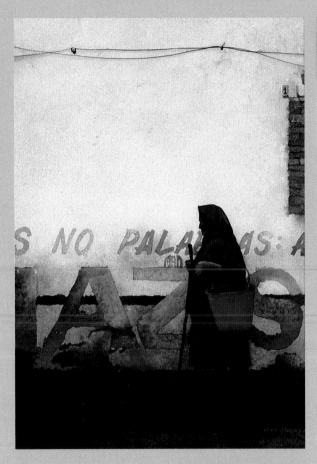

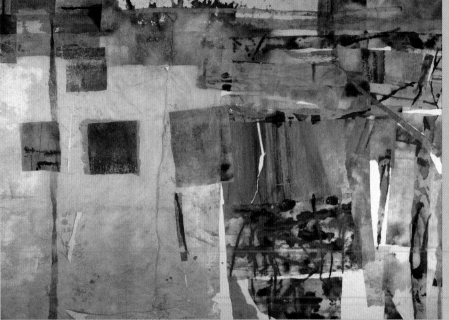

CARMELA C. GRUNWALDT
RETREAT
30" x 40" (76.2 cm x 101.6 cm)
140 lb. hot press

JUDY MORRIS, N.W.S.
AJIJIC'S PEANUT VENDER
20" x 28" (50.8 cm x 71.1 cm)
Arches 300 lb. cold press

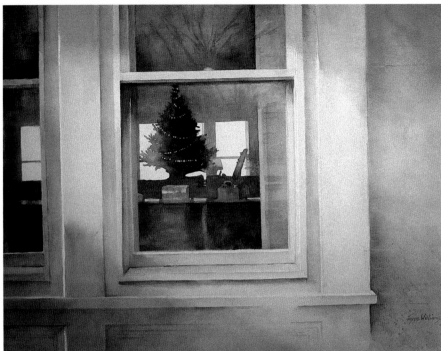

JOYCE WILLIAMS, A.W.S., N.W.S.

TABLE TOP TREE

22" x 30" (55.9 cm x 76.2 cm)

Strathmore Gemini 300 lb. cold press

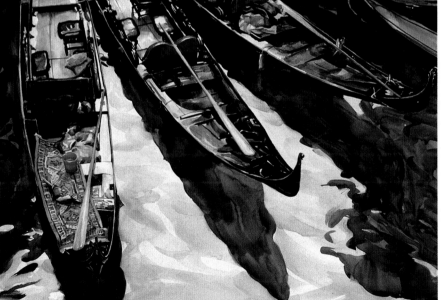

GERALD J. FRITZLER,
N.W.S., M.W.S., C.W.S.

GONDOLA'S

18.25" x 26.75" (46.4 cm x 67.9 cm)

Strathmore 115 lb. hot press

MARY BRITTEN LYNCH

CARIBBEAN CRUISE, 2

30" x 20" (76.3 cm x 50.8 cm)

Arches 300 lb. cold press

Media: Transparent watercolor,
acrylic, gesso

KAREN FREY

BOY WITH BLUE CAP

14" x 20" (35.6 cm x 50.8 cm)

Lana Aquarelle 140 lb. rough

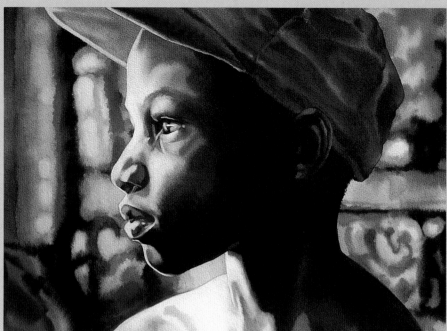

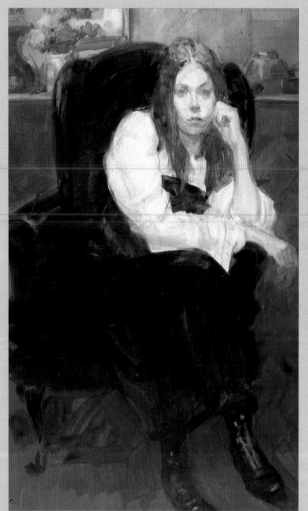

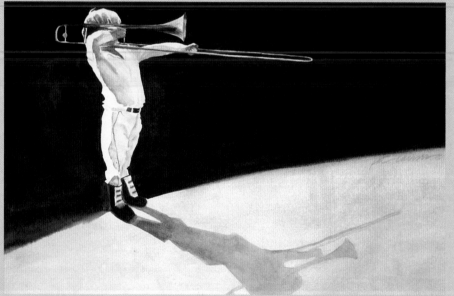

IRWIN GREENBERG

MADELINE

11" x 7" (27.9 cm x 17.8 cm)

Bristol 3-ply plate

PAT CAIRNS

MUSIC MAN

22" x 30" (55.9 cm x 76.2 cm)

Arches 140 lb. hot press

GEORGE JAMES

AWAY FROM THE WIND

25" x 38" (63.5 cm x 96.5 cm)

Synthetic Kimdura 140 lb. hot press

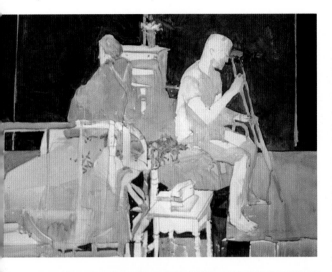

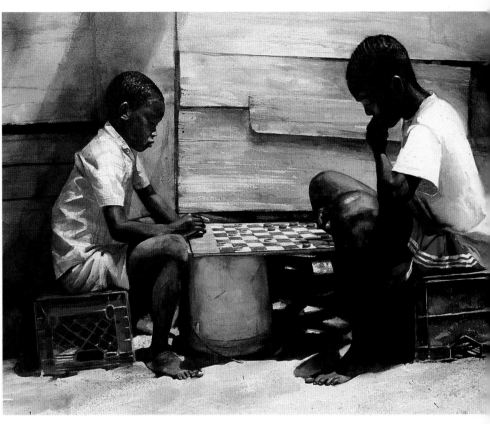

JERRY ROSE

THE CHECKER GAME

21" x 29" (53.3 cm x 73.7 cm)

Fabriano Artistico 140 lb. cold press

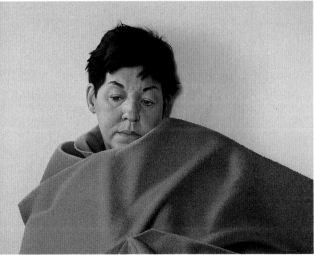

JOSEPH MANNING

UNTIL DEATH DO US PART

17.25" x 23.5" (43.8 cm x 59.7 cm)

Gesso on illustration board

Media: Egg tempera, watercolor

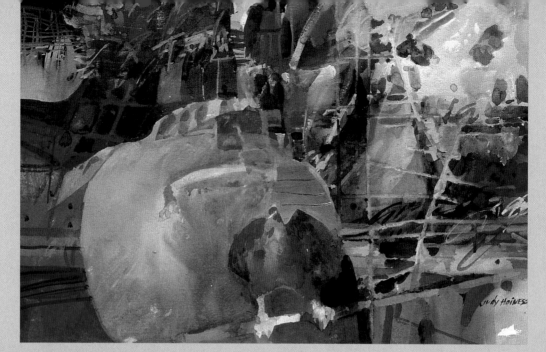

JUDY A. HOINESS

BIRD AND BOUQUET

22" x 30" (55.9 cm x 76.2 cm)

300 lb. cold press

MAXINE CUSTER

JEWELS OF DISCOVERY

22" x 30" (55.9 cm x 76.2 cm)

Arches 140 lb.

Media: Watercolor, acrylic

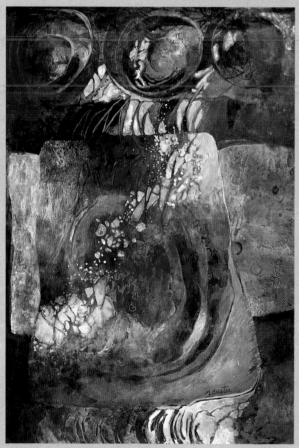

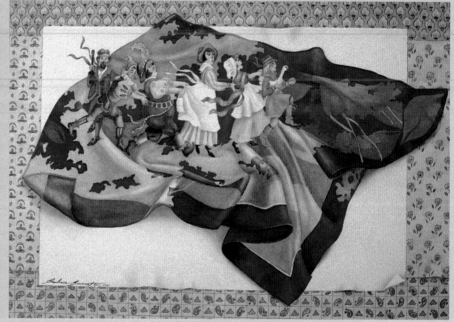

BARBARA BURNETT

PURSUIT OF THE GOLD

15" x 21" (38.1 cm x 53.3 cm)

Arches 140 lb. hot press

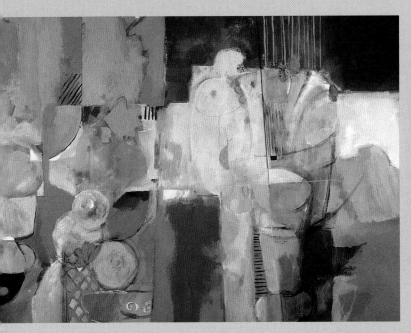

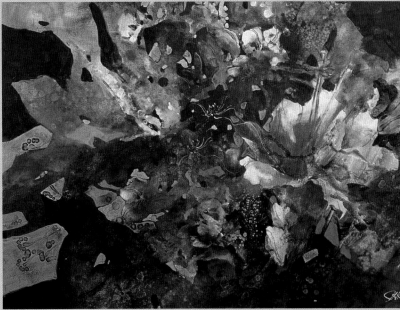

BARBARA MILLICAN
STILL LIFE TAPESTRY
22" x 30" (55.9 cm x 76.2 cm)
Arches 140 lb. cold press
Media: Acrylic

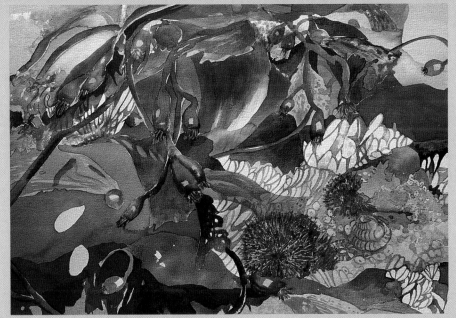

JOYCE H. KAMIKURA,
F.C.A., N.W.S.
MYSTIC ARRANGEMENT
22" x 30" (55.9 cm x 76.2 cm)
Arches 140 lb. cold press
Media: Acrylic

RUTH HICKOK
SCHUBERT, W.W.,
N.W.W.S.
SHOAL OF BARNACLES
22" x 30" (55.9 cm x 76.2 cm)
Arches 300 lb. cold press

JEAN SNOW

THRU THE GLASS

15" x 20" (38.1 cm x 50.8 cm)

Arches 90 lb. cold press

Media: Acrylic, watercolor, collage

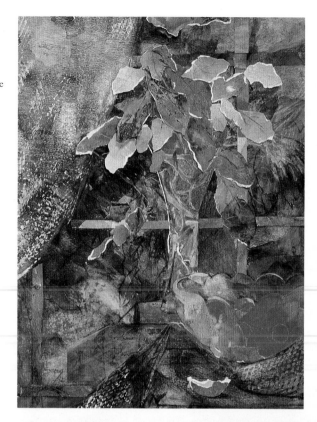

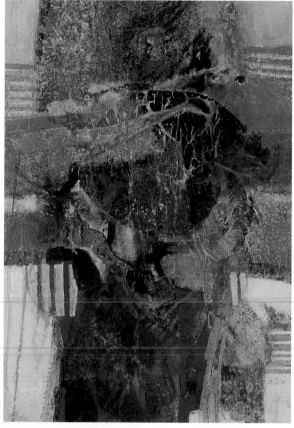

BELLE OSIPOW

THE FORBIDDEN FRUIT

19" x 27" (48.3 cm x 68.6 cm)

Arches 140 lb.

Media: Watercolor, acrylic, collage

BARBARA LEITES,

N.W.S., T.W.S., S.E.A.

EARTH V

22" x 30" (55.9 cm x 76.2 cm)

Strathmore Aquarius

Media: Acrylic

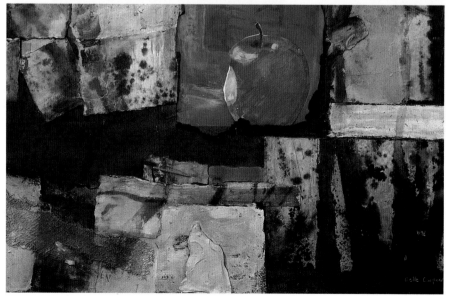

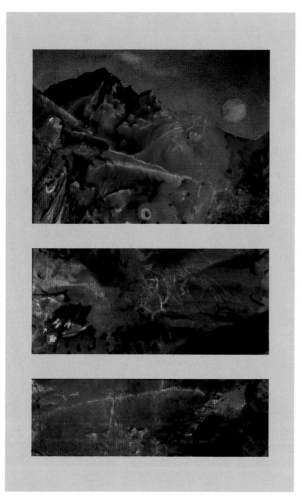

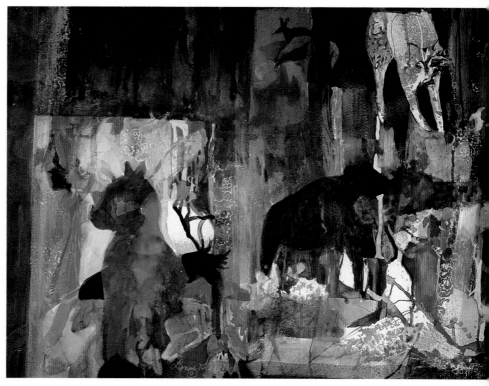

SANDY KINNAMON

MOONSCAPE

32" x 23" (81.3 cm x 58.4 cm)

Mead hot press

Media: Liquid acrylic, watercolor,

gouache

LYNNE KROLL

ANIMAL DREAMS

22" x 30" (55.9 cm x 76.2 cm)

Arches 140 lb. cold press

Media: Golden fluid acrylic,

gouache, watercolor

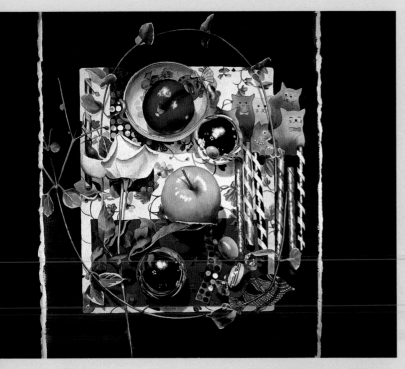

JANE FREY, N.W.S.

GREEN APPLÉ AND A

WHITE ROSE

21.5" x 25.5" (54.6 cm x 64.8 cm)

Arches 300 lb. cold press

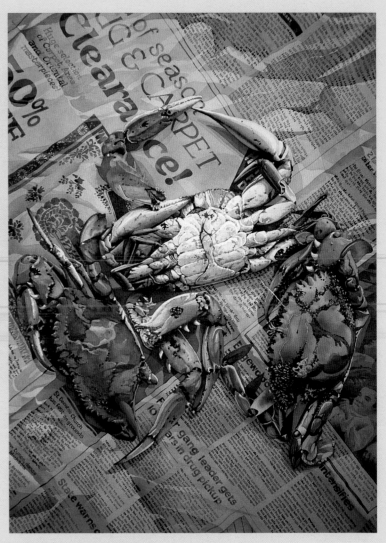

JOSEPH J. CORREALE, JR.

STEAMED IN MARYLAND

21" x 28" (53.3 cm x 71.1 cm)

Arches 140 lb. cold press

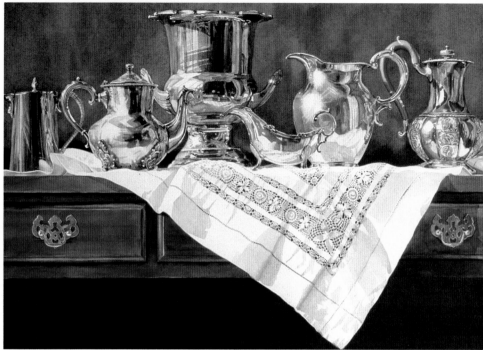

LIZ DONOVAN
SIX PIECES OF SILVER
22" x 35" (55.9 cm x 88.9 cm)
Arches 300 lb. cold press

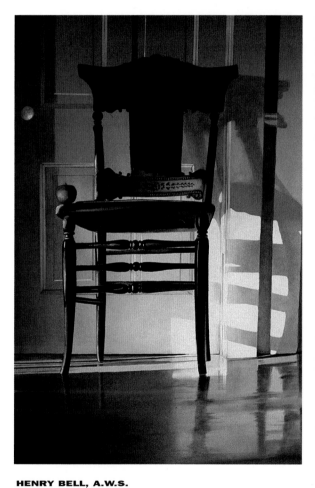

HENRY BELL, A.W.S.
THREE-QUARTER TIME
22" x 30" (55.9 cm x 76.2 cm)
260 lb. Arches hot press

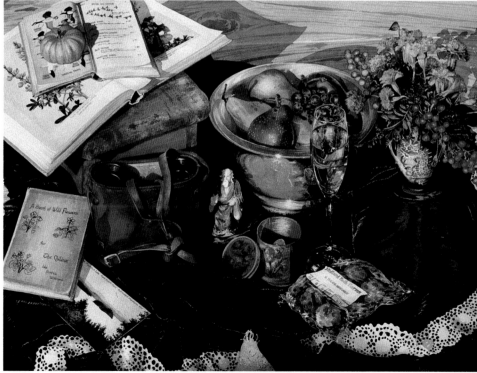

LAUREL LAKE MCGUIRE
AUTUMN PLEASURES
18" x 24" (45.7 cm x 60.9 cm)
Arches 140 lb.

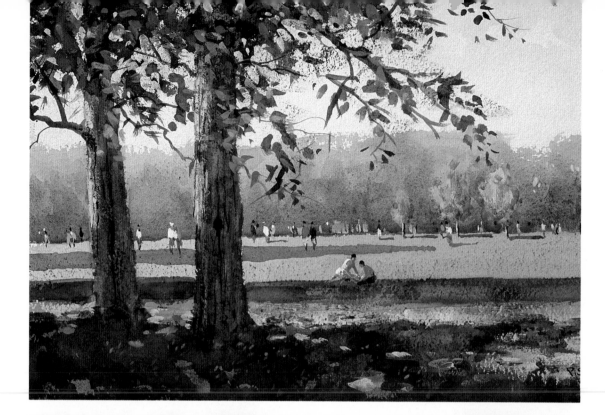

**PAUL STRISIK, N.A.,
A.W.S.**
HYDE PARK, LONDON
14" x 21" (35.6 cm x 53.3 cm)
J.B. Green 300 lb. cold press

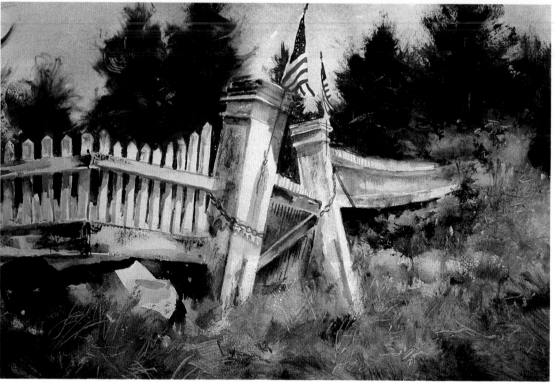

JOAN BORYTA
HALLOWED GROUND
15" x 22" (38.1 cm x 55.9 cm)
Winsor & Newton 140 lb. cold
press

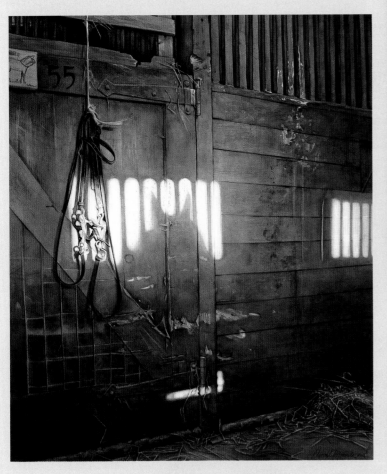

**DANIEL J. MARSULA, A.W.S.,
M.W.S**
STABLE
19.5" x 23.5" (49.5 cm x 59.7 cm)
Arches 140 lb. cold press

LORING W. COLEMAN
THE LAST CHAPTER
28.5" x 21" (72.4 cm x 53.3 cm)
E.H. Saunders 300 lb.

JOE JAQUA

POWELL STREET, SAN
FRANCISCO

18" x 25" (45.7 cm x 63.5 cm)

300 lb. cold press

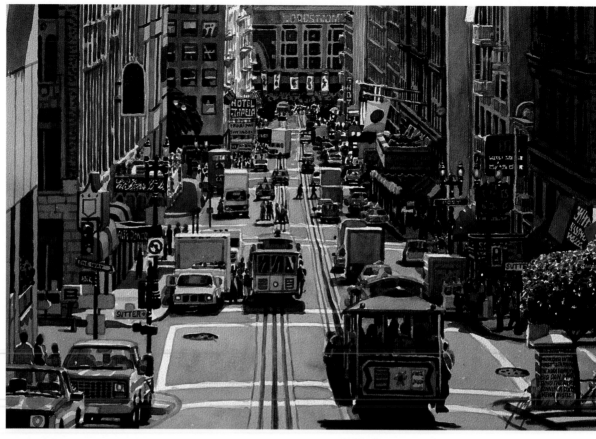

MARGE CHAVOOSHIAN

HARBOR IN
PORTOVENERA

22" x 30" (55.9 cm x 76.2 cm)

Arches 140 lb. cold press

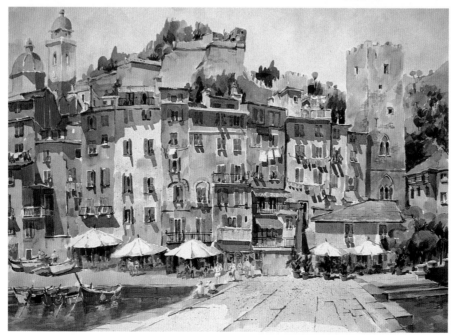

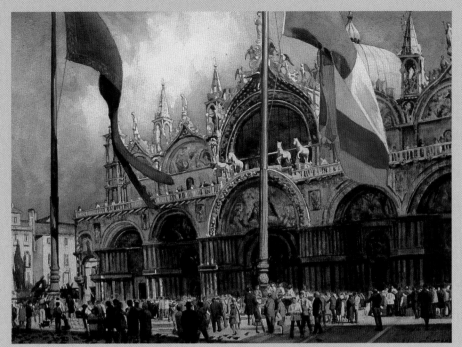

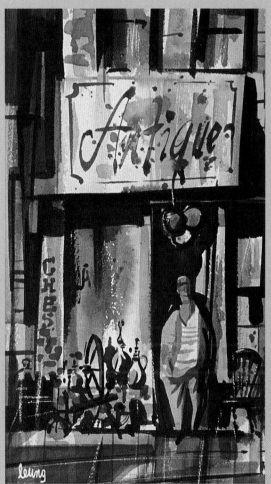

JOSEPH SANTORO, N.A.
SAINT MARKS - VENICE
21" x 29" (53.3 cm x 73.7 cm)
Arches 300 lb.

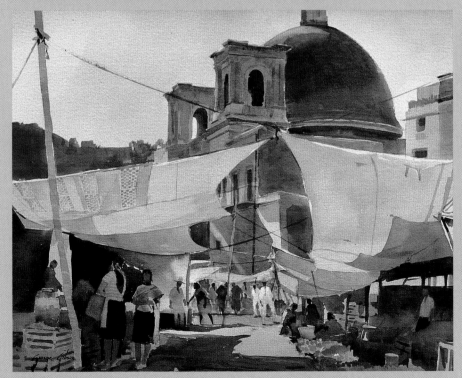

GEORGE GIBSON, N.A., A.W.S., N.W.S.MARKET DAY -
GUANAJUATO
22" x 30" (55.9 cm x 76.2 cm)
Arches 300 lb. rough

MONROE LEUNG
PAWN SHOP
15.5" x 22" (38.4 cm x 55.9 cm)
Arches 140 lb. cold press

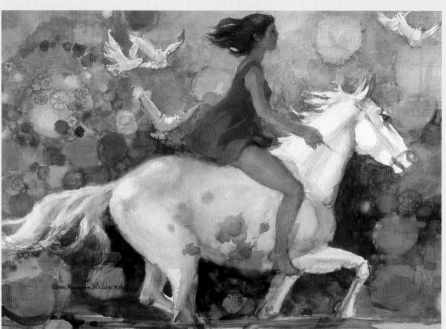

EILEEN MONAGHAN WHITAKER

SHE RIDES A WHITE HORSE

22" x 30" (55.9 cm x 76.2 cm)

300 lb. cold press

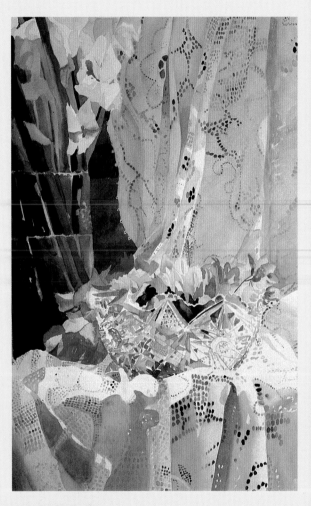

PAT FORTUNATO

COLLECTIBLES I

30" x 22" (76.2 cm x 55.9 cm)

Waterford 140 lb. cold press

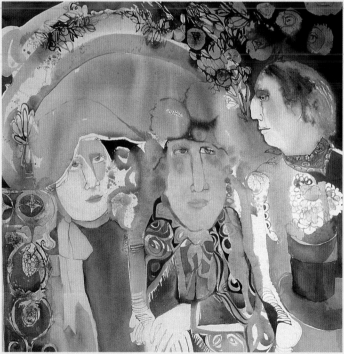

KAREN B. BUTLER

COURT OF TWO SISTERS

36" x 36" (91.4 cm x 91.4 cm)

Arches 140 lb. cold press

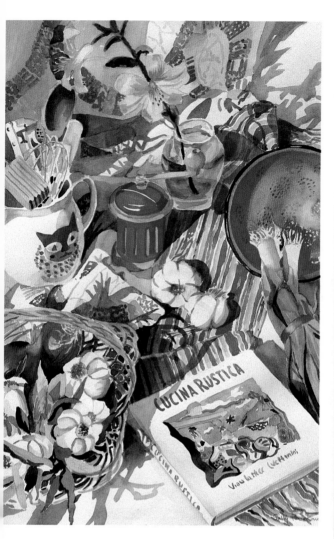

SALLY BOOKMAN

CUCINA RUSTICA

18" x 24" (45.7 cm x 60.9 cm)

Arches 140 lb. cold press

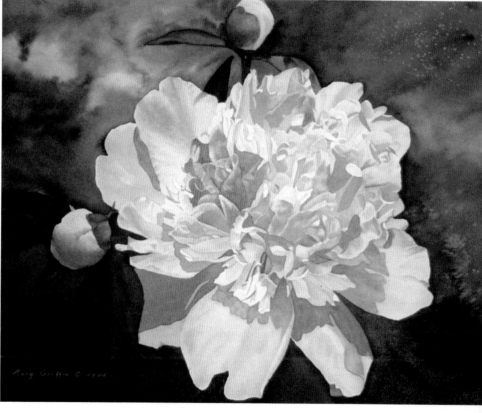

MARY GRIFFIN,

N.E.W.S.

PINK AND WHITE PEONY

30" x 22" (76.2 cm x 55.9 cm)

Arches 300 lb. cold press

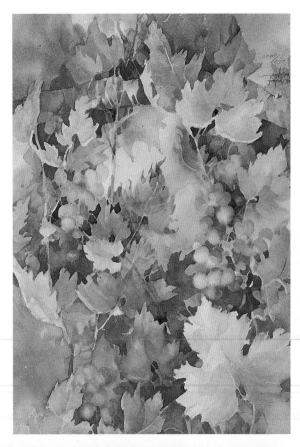

MARGARET HOYBACH

VINTAGE YEAR

22" x 30" (55.9 cm x 76.2 cm)

Arches 300 lb. cold press

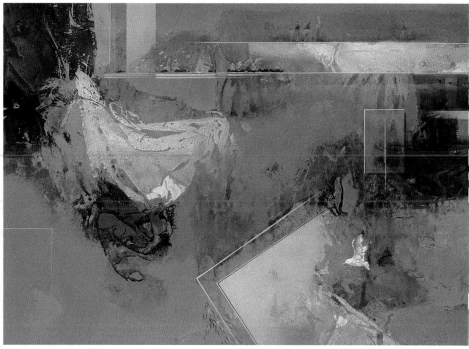

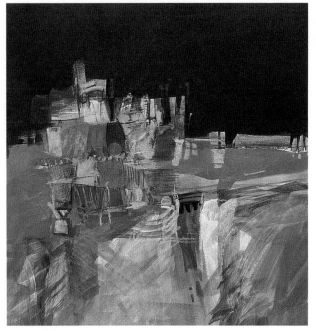

ROBERT S. OLIVER,
A.W.S.

NIGHT SCAPE

14" x 14" (35.6 cm x 35.6 cm)

Arches 140 lb. hot press

Media: Watercolor, acrylic, char-

coal, watercolor pencils, opaque

watercolor pastels

DOUG PASEK

SEARCHING FOR ALICE

WONDERLAND

36" x 28" (91.4 cm x 71.1 cm)

Strathmore #112

Media: Acrylic, transparent and

opaque watercolor

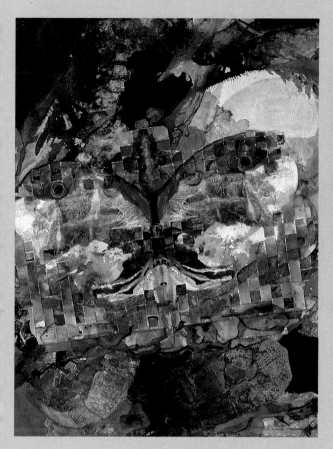

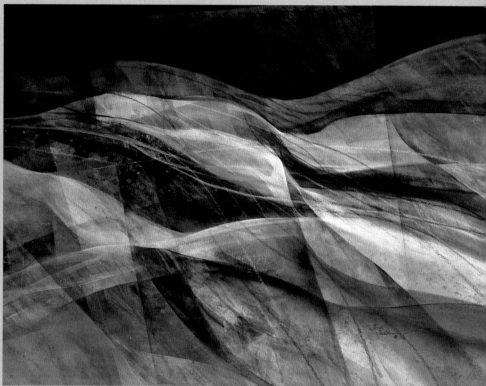

MARGARET C. MANTER
FIREBUG
30.25" x 23.5" (76.8 cm x 59.7 cm)
Arches 140 lb. cold press,
Strathmore Aquarius II 90 lb.
Media: Watercolor, Golden and
Grumbacher acrylic, Pelikan ink

FREDI TADDEUCCI
RIVER'S CREST
21.25" x 28.75" (54 cm x 73 cm)
Arches 140 lb. cold press
Media: Watercolor, acrylic, colored pencil

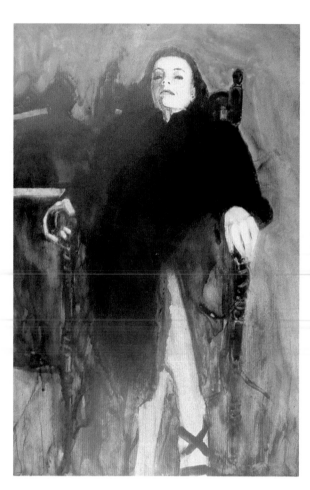

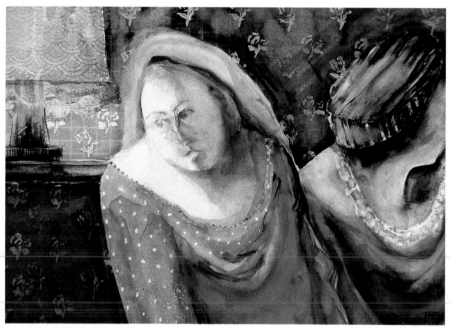

PAULA TEMPLE
VISITING SISTER
24" x 36" (60.9 cm x 91.4 cm)
Morilla
Media: Collage of textured rice
paper, gold sticker dots

J.A. EISER
TRANQUILITY
15" x 11" (38.1 cm x 27.9 cm)
Bristol 3-ply

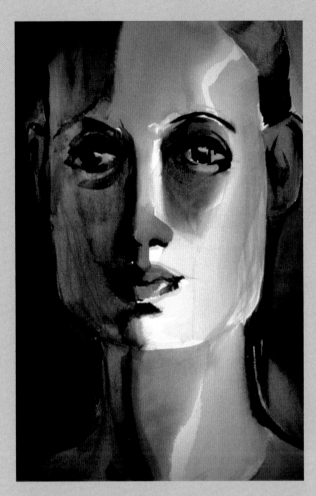

LANCE R. MIYAMOTO, N.W.S.
SIBYL (PERSIAN)
24" x 19" (60.9 cm x 48.3 cm)
Arches 140 lb. rough

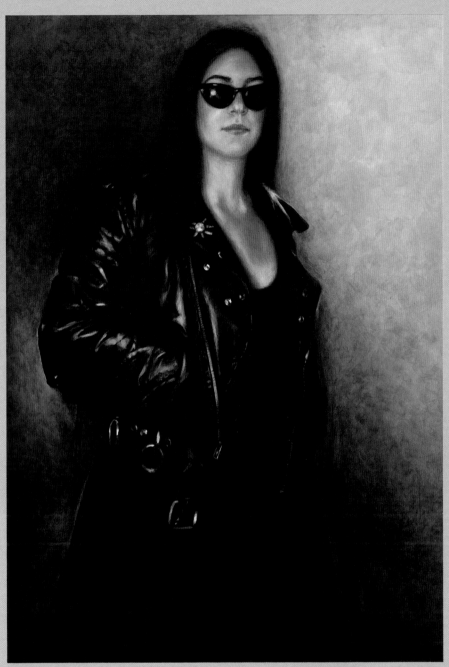

JANE BREGOLI
CREPUSCULE IN BLACK & BROWN: WENDY
40" x 30" (101.6 cm x 76.2 cm)
Strathmore 4-ply bristol hot press medium surface

PATRICIA WYGANT

PAROIKIA AFTERNOON

27" x 39" (68.9 cm x 99.1 cm)

Arches 300 lb. cold press

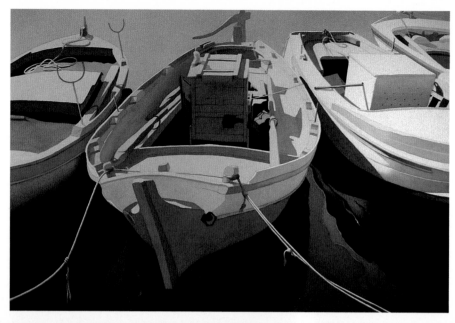

JULIAN BLOOM

TEA WITH MADELINE

22" x 30" (55.9 cm x 76.2 cm)

Arches 300 lb. cold press

CHARLES F. BARNARD

LOOKING BACK

26.25" x 20.5" (66.7 cm x 52.1cm)

Arches 300 lb. cold press

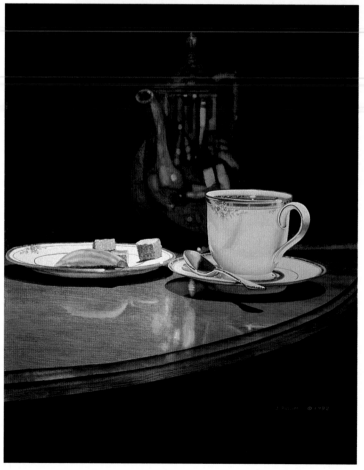

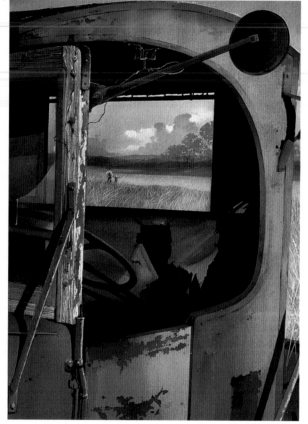

T. THOMAS GILFILEN

FRIEDERICK'S TRUNK

20" x 30" (50.8 cm x 76.2 cm)

Winsor & Newton 260 lb.

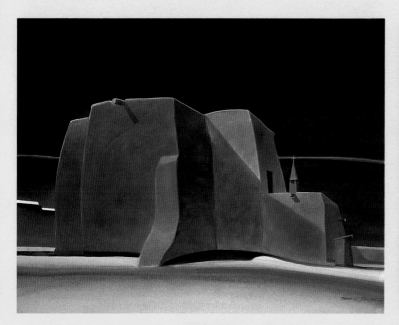

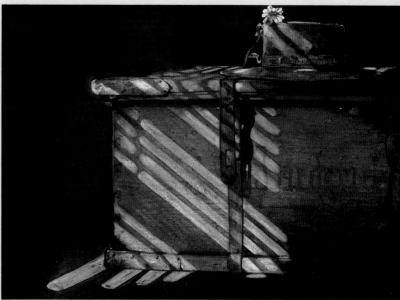

DONAL JOLLEY

CHAPEL, LAS TRAMPAS

22" x 30" (55.9 cm x 76.2 cm)

Arches 300 lb. cold press

Media: Liquitex acrylic

CAROL ANN SCHRADER

MUMPER'S COMPETITION

21" x 29" (53.3 cm x 73.7 cm)

Arches 300 lb. cold press

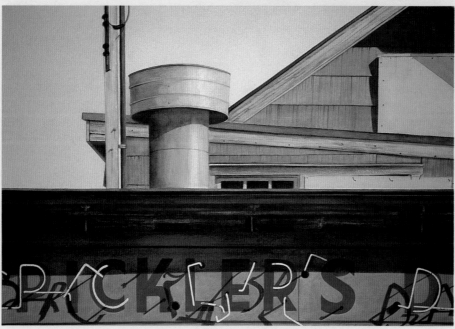

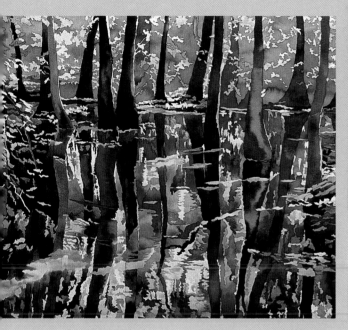

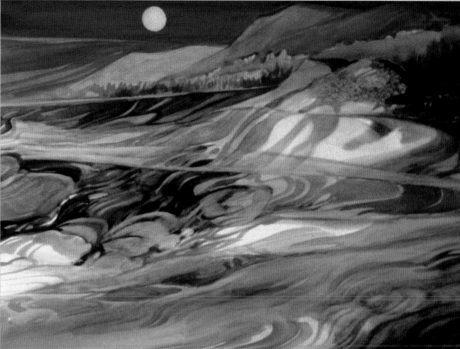

MARY ANN POPE
BEAVERDAM SWAMP IV
26" x 22" (66 cm x 55.9 cm)
Lana Aquarelle 140 lb. watercolor
paper

SARA ROUSH
TIDEWATER
22" x 30" (55.9 cm x 76.2 cm)
Lana Aquarelle 140 lb. cold press
Media: Mixed water media,
gouache

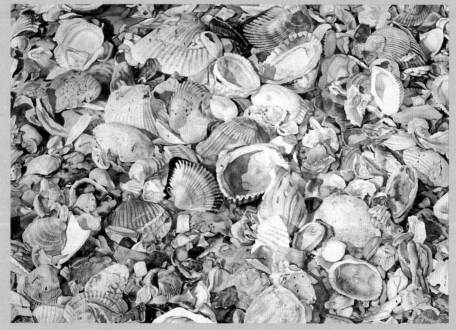

ELAINE HAHN
SUNLIT TREASURES
22" x 30" (55.9 cm x 76.2 cm)
Arches 300 lb. cold press

SANDRA HUMPHRIES
GOOD MORNING,
ALBUQUERQUE
22" x 30" (55.9 cm x 76.2 cm)
Arches 300 lb. cold press
Media: Transparent watercolor,
acrylic

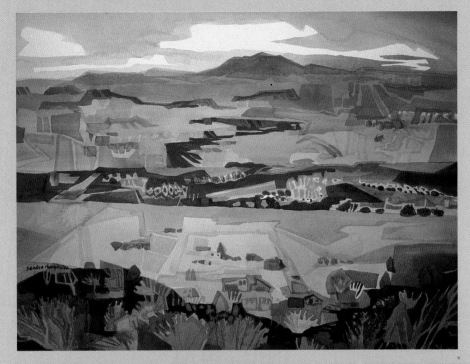

GLORIA PATERSON
LITE PLANE SPACE I
22" x 31" (55.9 cm x 78.7 cm)
Rives BFK, primed with gesso

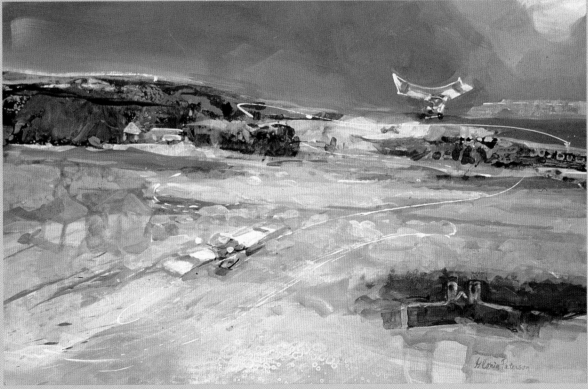

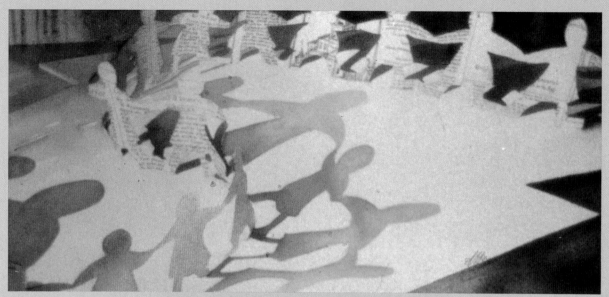

ANITA MEYNIG

POP-THE-WHIP

10" x 22" (25.4 cm x 55.9 cm)

Arches 140 lb. cold press

Media: Watercolor, ink

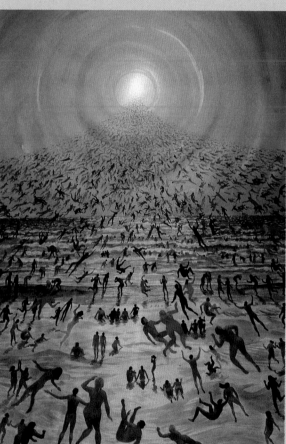

MICHAEL FRARY

FACTORY RECALL

42" x 30" (106.7 cm x 76.2 cm)

Arches Imperial 140 lb. cold press

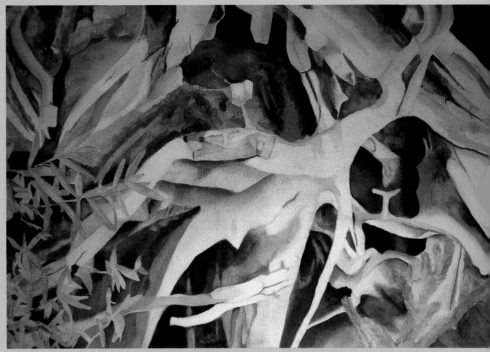

THEODORA T. TILTON
HIDDEN DEPTH
12" x 21" (30.5 cm x 53.3 cm)
Arches 140 lb. cold press

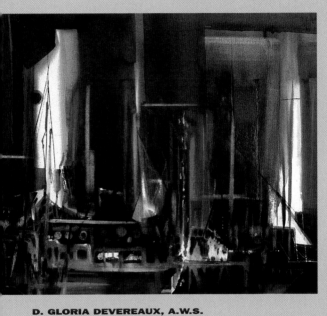

D. GLORIA DEVEREAUX, A.W.S.
BLACK DRAGON SALVAGE
22" x 30" (55.9 cm x 76.2 cm)
140 lb. cold press

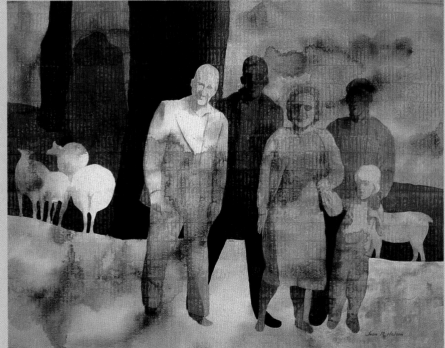

JEAN R. NELSON
TOURISTS V; AVEBURY
22" x 30" (55.9 cm x 76.2 cm)
Waterford 140 lb. cold press
Media: Acrylic and watercolor over acrylic medium grid

61

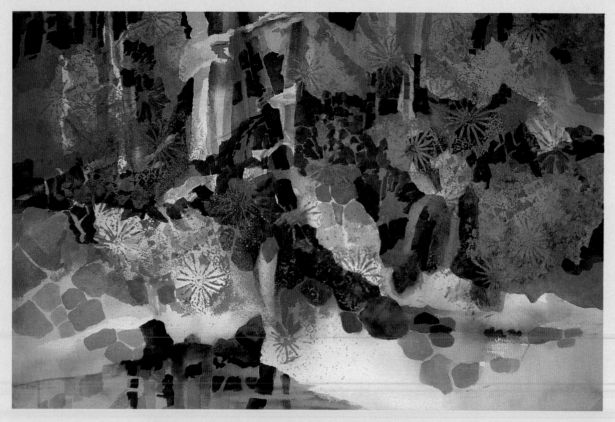

PATRICIA REYNOLDS, M.W.S.
WINTER WEFT
22" x 30" (55.9 cm x 76.2 cm)
Arches 400 lb. cold press

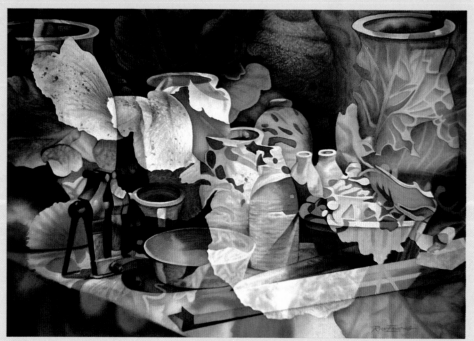

RICH ERNSTING
THYME IN A BOTTLE
27" x 39" (68.6 cm x 99.1 cm)
Arches 555 lb. cold press

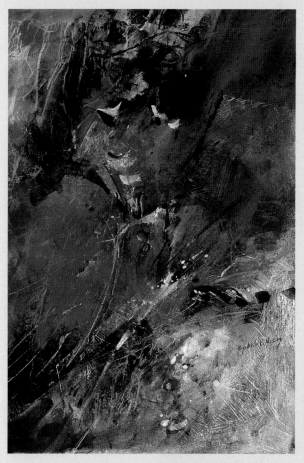

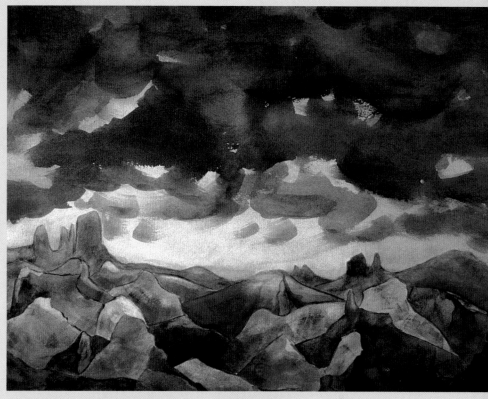

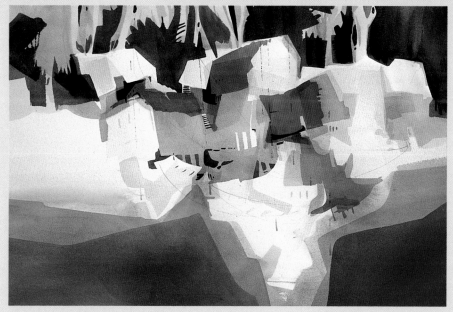

OPHELIA B. MASSEY
IMPRESSIONS, I
28" x 20" (71.1 cm x 50.8 cm)
Crescent 110 lb.

**PAT DEADMAN, A.W.S.,
N.W.S.**
CANEEL BAY
22" x 30" (55.9 cm x 76.2 cm)
Arches 140 cold press

DIANE VAN NOORD
THUNDER
18" x 24" (45.7 cm x 60.9 cm)
Arches 140 lb. cold press

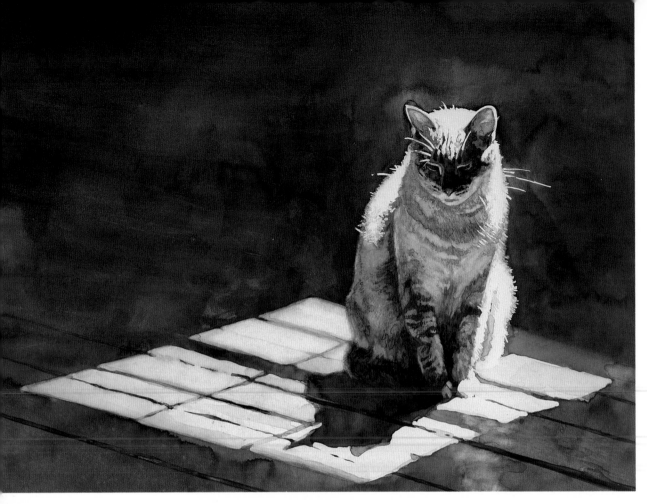

DEBORAH L. CHABRAN

MUGS IN SUNLIGHT

9" x 12" (22.9 cm x 30.5 cm)

Strathmore 4-ply bristol hot press

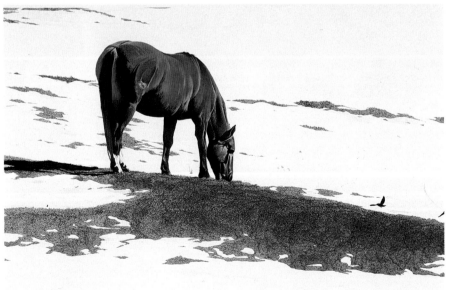

BEN WATSON III

HARMONY

15.5" x 28" (39.4 cm x 71.1 cm)

Strathmore 4-ply medium surface

Media: Watercolor, gouache

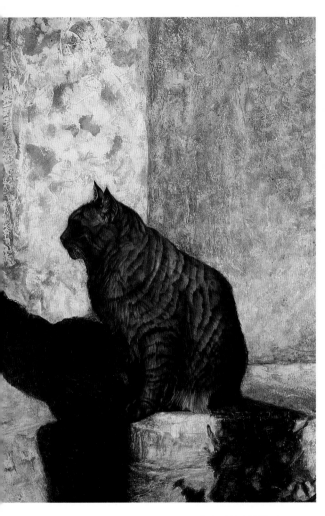

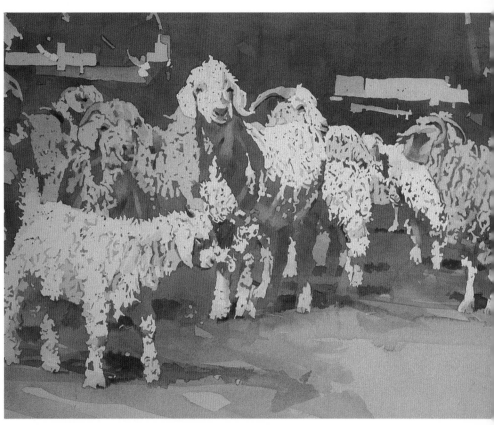

JUDI BETTS, A.W.S.

CARNIVAL CHARACTERS

22" x 30" (55.9 cm x 76.2 cm)

Arches 140 lb. cold press

JANET N. HEATON

ALSACE CHURCH CAT

23" x 17" (58.4 cm x 43.2 cm)

Media: Egg tempera, watercolor

RUTH L. REINEL

CABBAGE

15" x 22" (38.1 cm x 55.9 cm)

Arches 140 lb. cold press

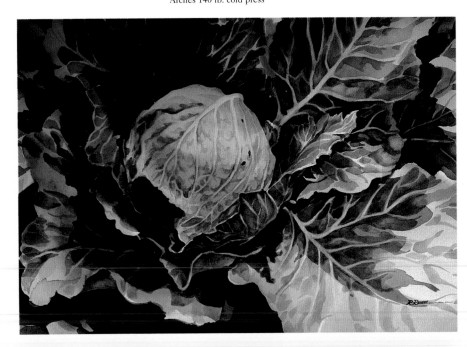

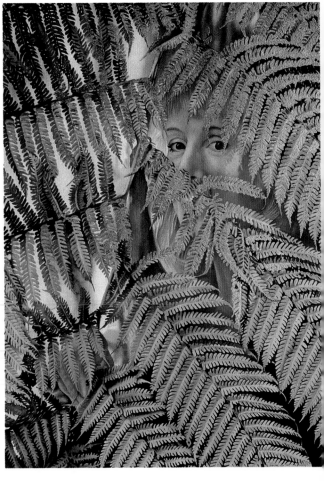

LINDA L. (STEVENS) MOYER

THE SIXTH DAY

42" x 29.5" (106.7 cm x 74.9 cm)

Arches 300 lb. rough

Media: Transparent watercolor, 23 carat gold leaf

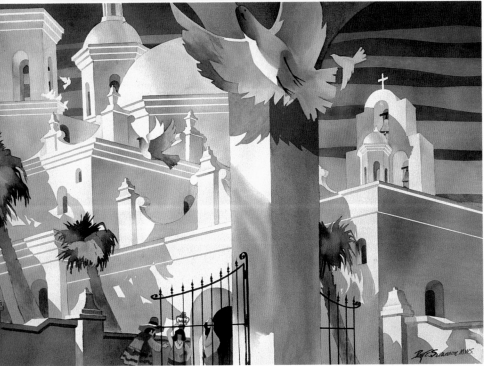

ROY E. SWANSON, M.W.S.

DOVE OF THE DESERT

25" x 35" (63.5 cm x 88.8 cm)

Arches 140 lb. cold press

GEORGIA A. NEWTON

PATTERNS OF AQUILEGIA

22" x 30" (55.9 cm x 76.2 cm)

Arches 140 lb. hot press

CECIE BORSCHOW

DOMINICAN COURTYARD

22" x 33" (55.9 cm x 83.8 cm)

Arches 140 lb.

**MARGARET SCANLAN,
A.W.S., W.H.S.**

MEADOW II

30" x 40" (76.2 cm x 101.6 cm)

Strathmore 500 Series heavy
weight

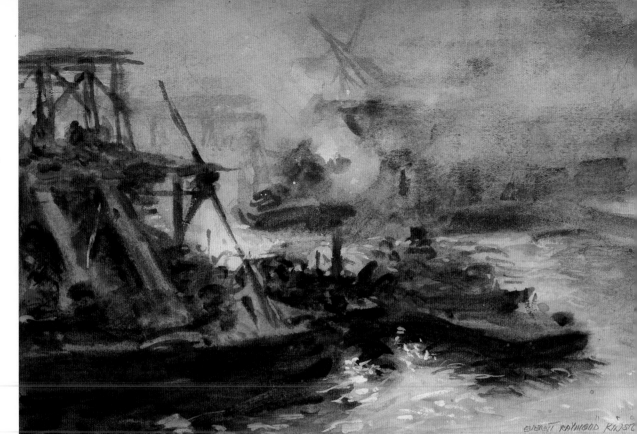

**EVERETT RAYMOND
KINSTLER, N.A., A.W.S.,
P.S.A.**
WATERFRONT, LONDON
6" x 10" (15.2 cm x 25.4 cm)
Slightexture P & O hot press

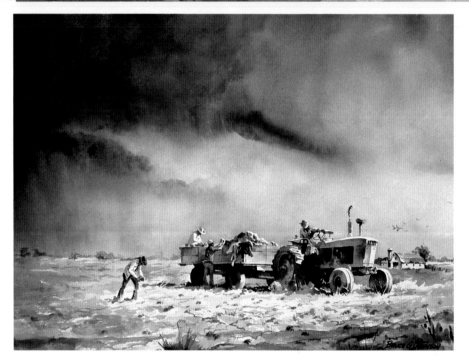

BRUCE G. JOHNSON
HURRYIN' HARVEST
21" x 29" (53.3 cm x 73.6 cm)
Arches 300 lb. cold press

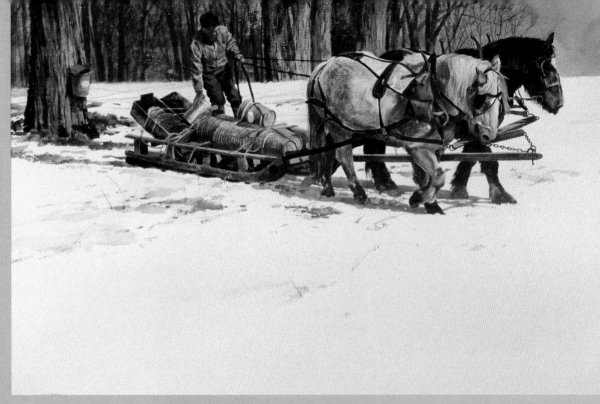

**DON STONE, N.A.,
A.W.S.**
THE UPPER GROVE
21.5" x 29.5" (54.6 cm x 74.9 cm)
Arches 140 lb.

**JORGE BOWENFORBES,
A.W.S., N.W.S.**
UITVLUGT
30" x 40" (76.2 cm x 101.6 cm)
Arches medium

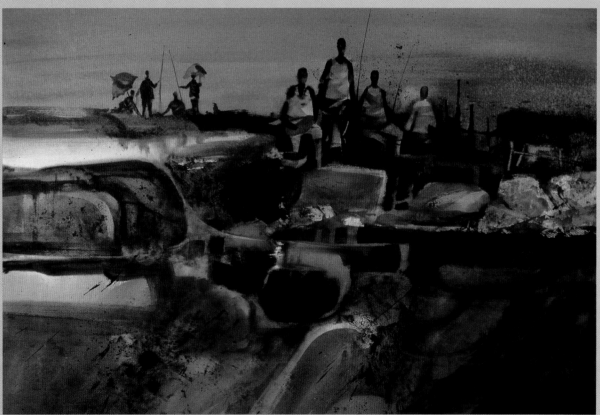

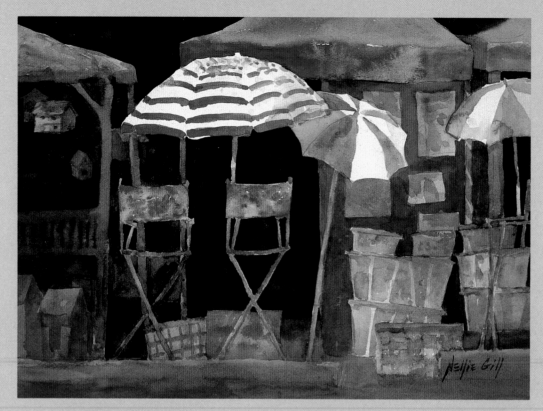

NELLIE GILL

PLEIN AIR PERSONALITIES

11" x 15" (27.9 cm x 38.1 cm)

Arches 140 lb. cold press

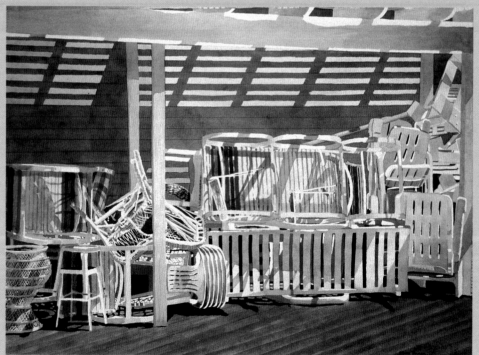

LINDA BAKER

ANTICIPATION V

22" x 30" (55.9 cm x 76.2 cm)

Arches 300 lb.

MARJEAN WILLETT

DOORS OF THERA

22" x 30" (55.9 cm x 76.2 cm)

Arches 140 lb. cold press

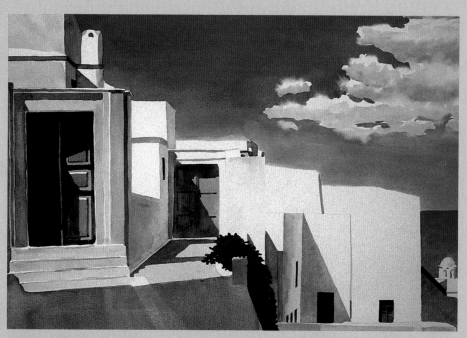

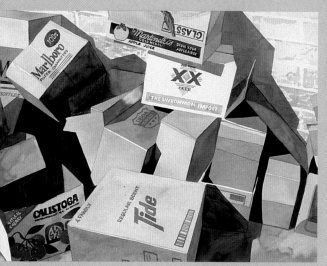

SHARON TOWLE

COLLECTIONS: BOXES

22" x 30" (55.9 cm x 76.2 cm)

Arches 140 lb. cold press

KAREN MATHIS

Marina Morning

22" x 36" (55.9 cm x 91.4 cm)

Arches 140 lb. cold press

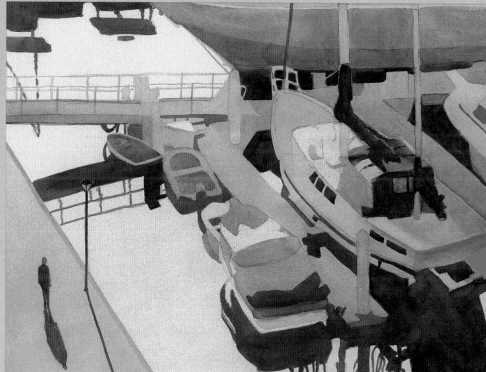

JAMES VANCE, A.W.S.
WEST BOTTOMS COLD
22" x 14.5" (55.9 cm x 36.8 cm)
Arches 150 lb. rough

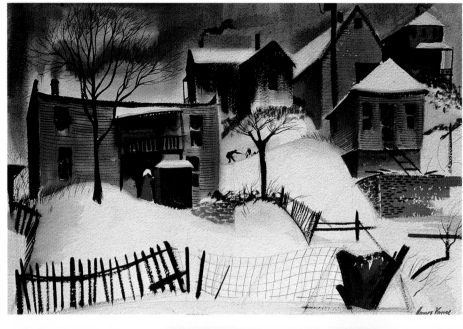

LAWRENCE R. BRULLO
IL PASSIONATO
30" x 22" (76.2 cm x 55.9 cm)
Arches 140 lb. cold press, rice
paper
Media: Torn and glued acid-free
paper, acrylic

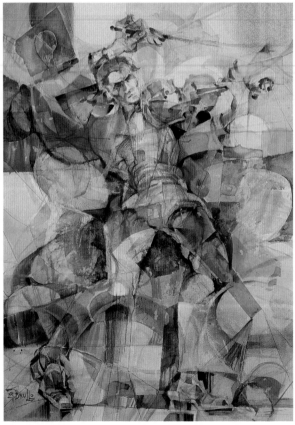

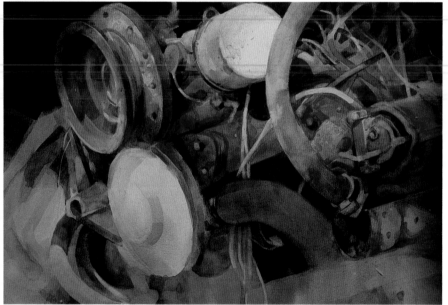

EDWARD MINCHIN, A.W.S.
A TIME TO REST
21.5" x 28.5" (54.6 cm x 72.4 cm)
Arches 140 lb. cold press

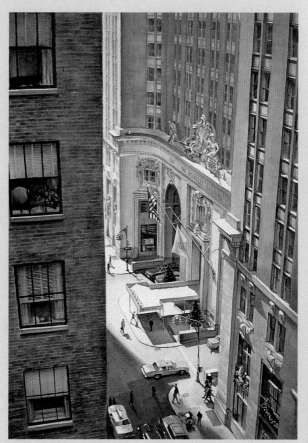

LOIS SALMON TOOLE
PARK AVENUE
PERSPECTIVE
27.75" x 20.5" (70.2 cm x 51.8 cm)
Arches 300 lb. cold press

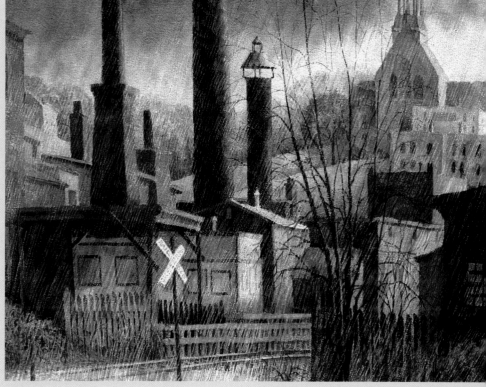

BECKY HALETKY
SUN SHOWER
20" x 28" (50.8 cm x 71.1 cm)
Arches 140 lb. rough

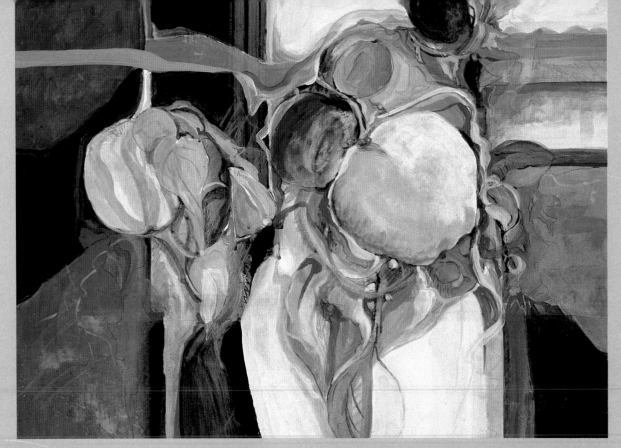

MARY ELLEN ANDREN, F.W.S.
RX: ONE DAILY
28" x 30" (71.1 cm x 76.2 cm)
Strathmore 114 lb.
Media: Watercolor, colored pencil, acrylic, crayon

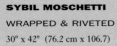

SYBIL MOSCHETTI
WRAPPED & RIVETED
30" x 42" (76.2 cm x 106.7)
Arches 300 lb. cold press

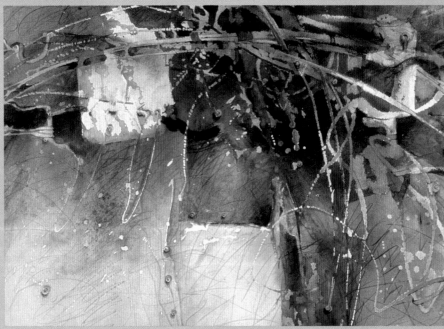

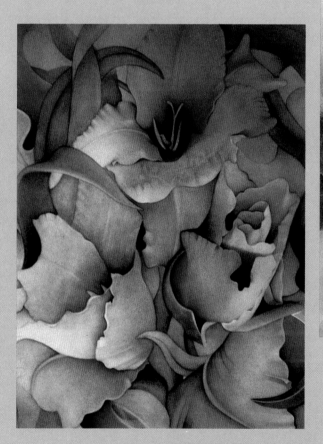

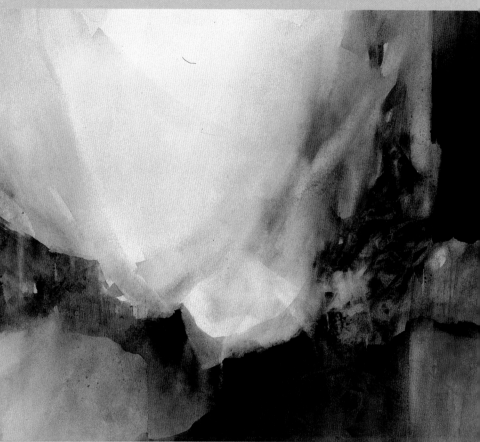

DOROTHY B. DALLAS
TERNATE RHYTHMS
22" x 30" (55.9 cm x 76.2 cm)
Arches 140 lb. cold press

SHARON WOODING
GLADIOLAS
22" x 30" (55.9 cm x 76.2 cm)
Arches 300 lb. cold press

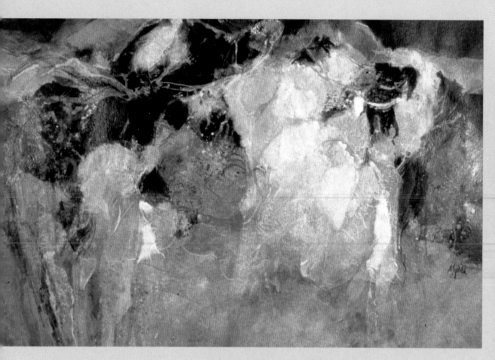

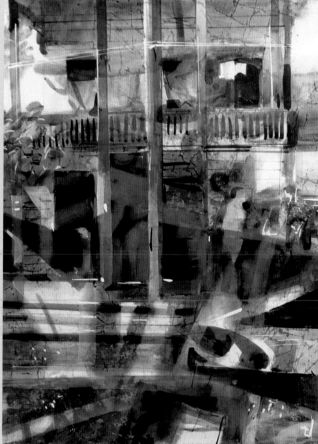

**CAROLE MYERS, A.W.S.,
N.W.S.**
ON THE BEACH
22" x 30" (55.9 cm x 76.2 cm)
Morilla 140 lb. cold press
Media: Watercolor, acrylic, collage

JANE OLIVER
FACADE, KEY WEST
20" x 25" (50.8 cm x 63.5 cm)
140 lb. hot press

HELLA BAILIN, A.W.S.
LEXINGTON LOCAL
23.5" x 34" (59.7 cm x 86.4 cm)
Whatman smooth
Media: Acrylic, watercolor

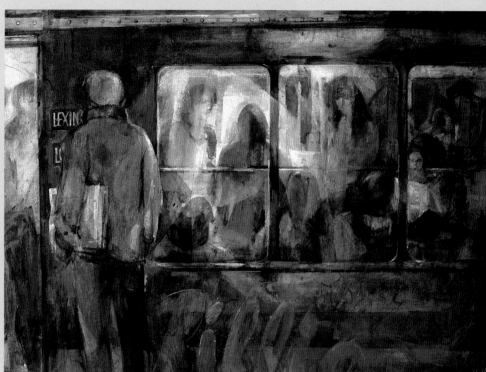

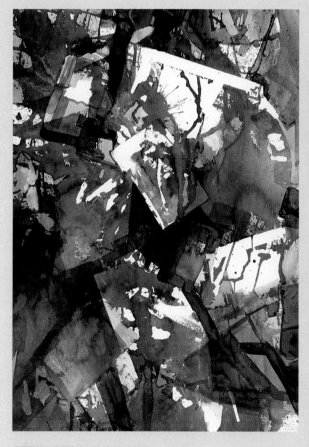

BETSY DILLARD STROUD
POSTCARDS FROM THE
EDGE #1
40" x 30" (101.6 cm x 76.2 cm)
Strathmore 114 lb.

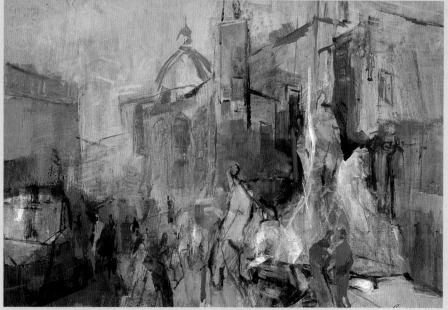

BETTY M. BOWES
ROMAN PIAZZA
25" x 36" (63.5 cm x 91.4 cm)
Sized Masonite

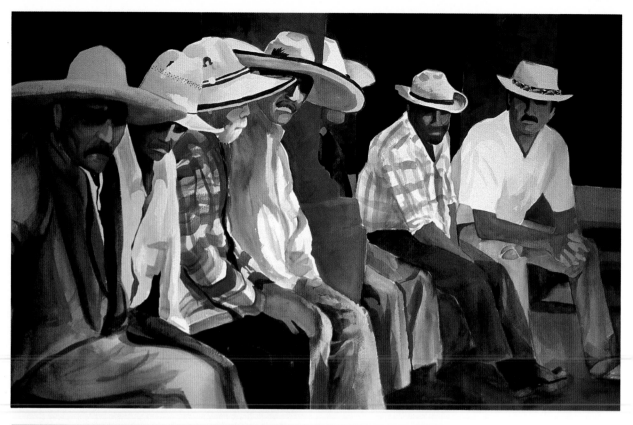

COLLEEN NEWPORT STEVENS

LOS AMIGOS

22" x 30" (55.9 cm x 76.2 cm)

Lana Aquarelle 555 lb.

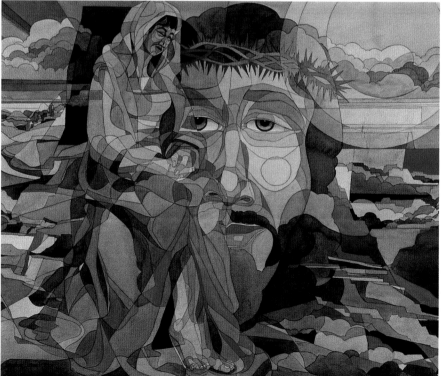

JOSEPH E. GREY II

THE PIETA

16" x 22" (40.6 cm x 55.8 cm)

Arches 140 lb. cold press

AVIE BIEDINGER

WEST ABOUT

22" x 30" (55.9 cm x 76.2 cm)

Arches 140 lb. cold press

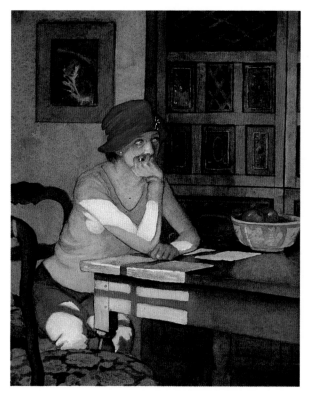

JADA ROWLAND

VERMEER'S TABLE

7.5" x 9.5" (19.1 cm x 24.1 cm)

Arches 140 lb. cold press

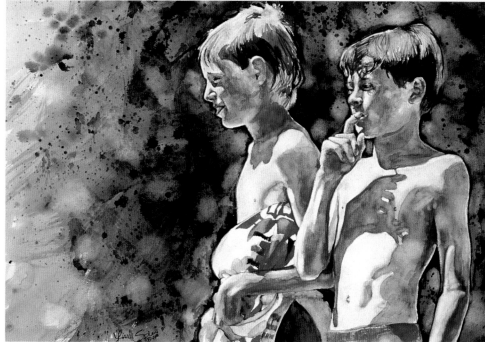

LINDA L. SPIES

BUBBLE GUM

20" x 27.5" (50.8 cm x 69.9 cm)

Arches 200 lb. cold press

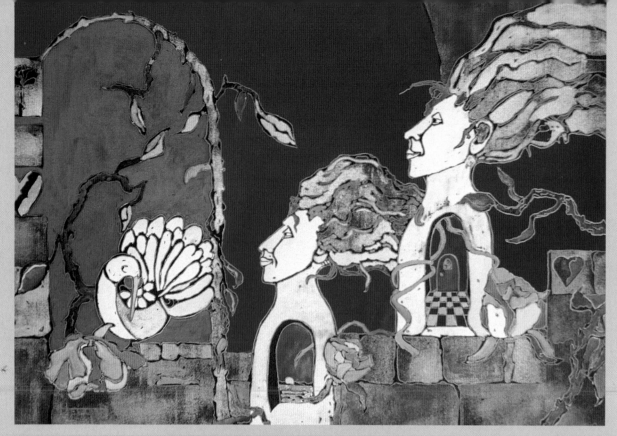

PHYLLIS HELLIER,
F.W.S, G.W.S., K.W.S.
DOORWAY TO BEYOND
22" x 30" (55.9 cm x 76.2 cm)
Arches 300 lb. cold press
Media: Gouache, ink resist, acrylic

PAT REGAN

HORSE OF THE GODDESS
OF THE MOON
22" x 30" (55.9 cm x 76.2 cm)
Arches 140 lb. cold press
Media: Watercolor, acrylic, gold
leaf

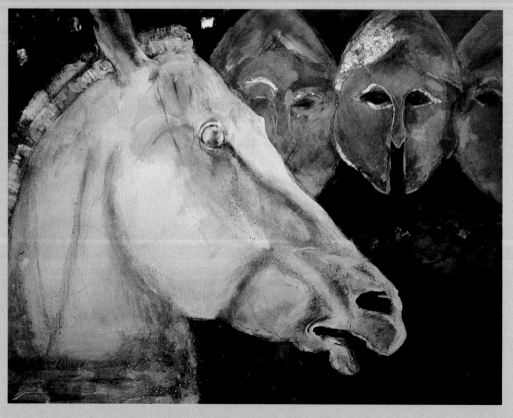

ELLEN FOUNTAIN

BUT WHAT WILL HE DO
FOR AN ENCORE?

22" x 30" (55.9 cm x 76.2 cm)

140 lb. cold press

Media: Watercolor, gouache, ink

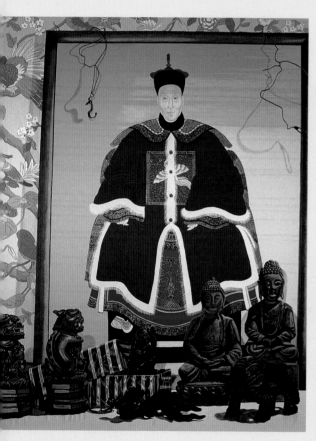

JANIS THEODORE

THE EMPEROR'S LAST

CALLING

42" x 35" (106.7 cm x 88.9 cm)

4-ply museum board

Media: Gouache

ZHENG-PING CHEN

STILL LIFE #1

22" x 30" (55.9 cm x 76.2 cm)

250 lb. cold press

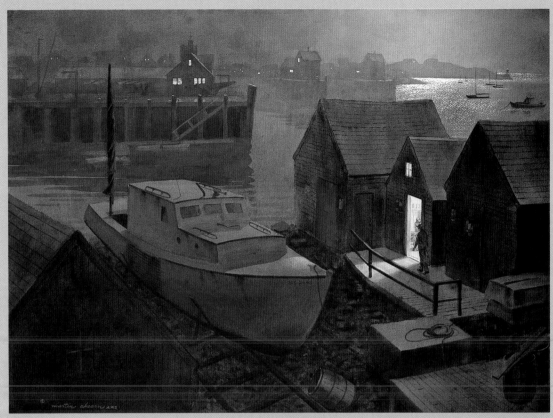

MARTIN R. AHEARN
MOONLITE, ROCKPORT
HARBOR
15" x 21" (38.1 cm x 53.3 cm)
Arches Elegant 240 lb.

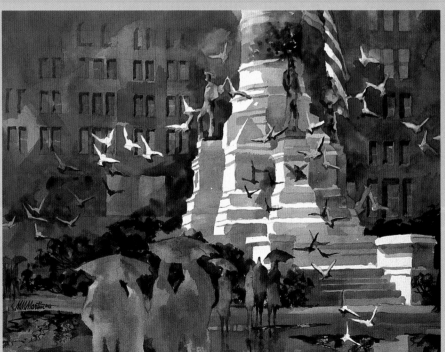

MARGARET M. MARTIN
SALUTE TO SOLDIERS
AND SAILORS
22" x 30" (55.9 cm x 76.2 cm)
Arches 300 lb. cold press

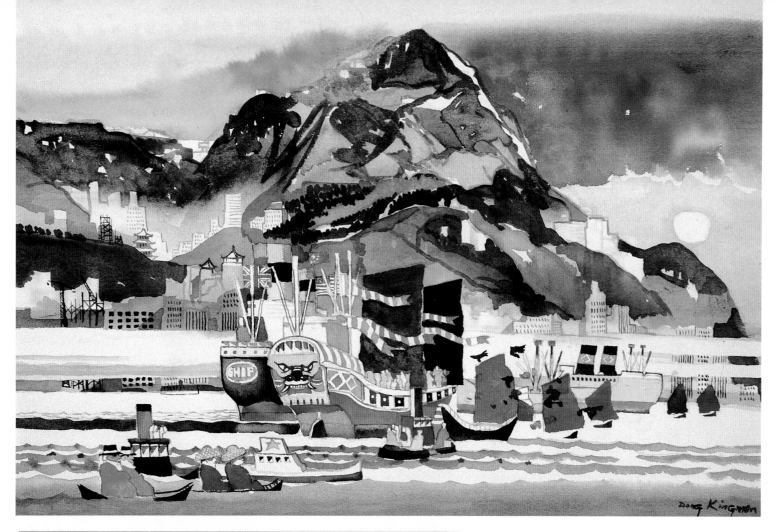

DONG KINGMAN

RED SAIL & EAST WIND

22" x 30" (55.9 cm x 76.2 cm)

Arches 300 lb.

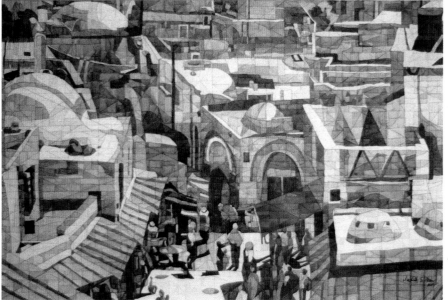

JUDITH S. REIN, M.W.S.

FROM THE DAMASCUS GATE

18" x 24" (45.7 cm x 60.9 cm)

Stonehenge cream printing paper

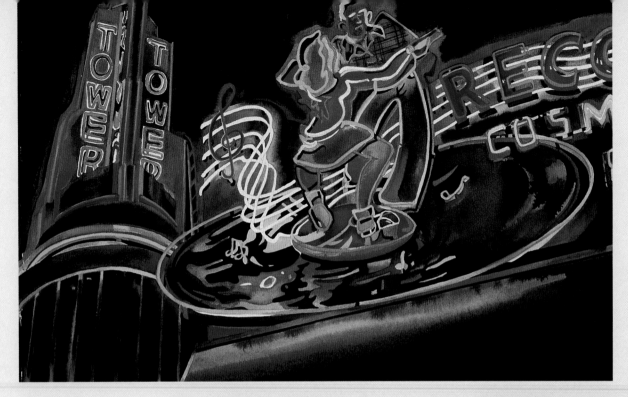

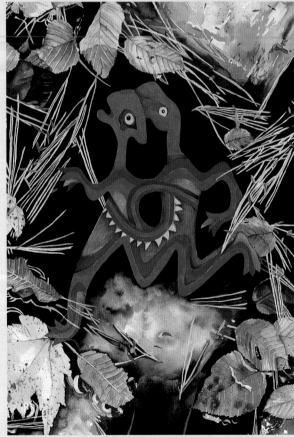

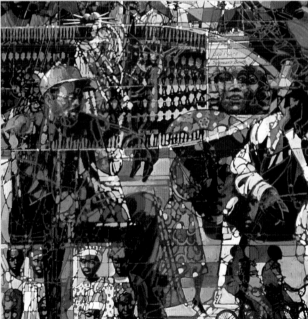

JILL FIGLER

TOWER TWO-STEP

15" x 20" (38.1 cm x 50.8 cm)

Arches 140 lb. cold press

**ELLNA GREGORY-
GOODRUM**

RITUAL LEAF DANCE

30" x 22" (76.2 cm x 55.9 cm)

Arches 140 lb. cold press

PAUL G. MELIA

MY BROTHER'S KEEPER

40" x 41" (101.6 cm x 104.1 cm)

310 illustration board

Media: Permanent inks, gouache

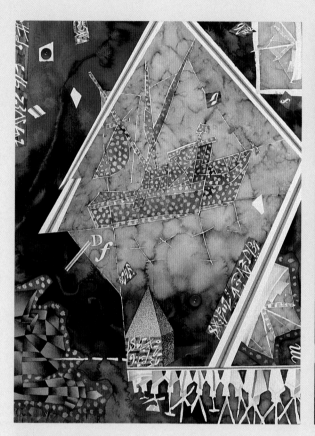

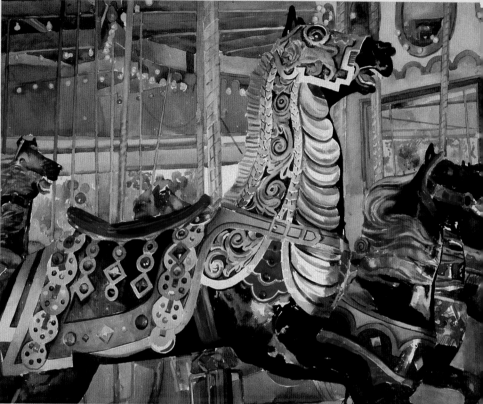

MILES G. BATT, SR.

ROCK MUSIC &
SHRIMPERS

29" x 21" (73.6 cm x 53.3 cm)

Arches 140 lb. cold press

SANDRA SAITTO

CAROUSEL #22

22" x 30" (55.9 cm x 76.2 cm)

Arches 140 lb. cold press

Media: Watercolor, gouache

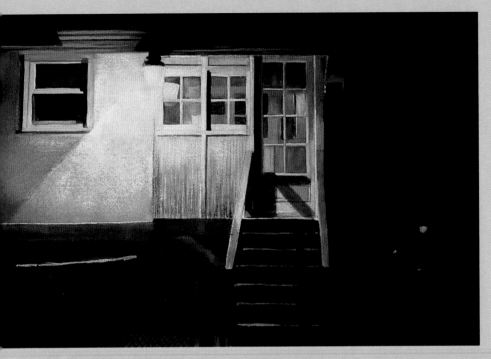

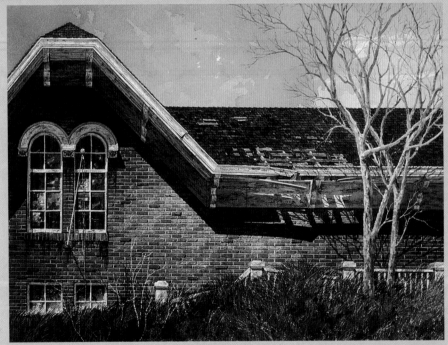

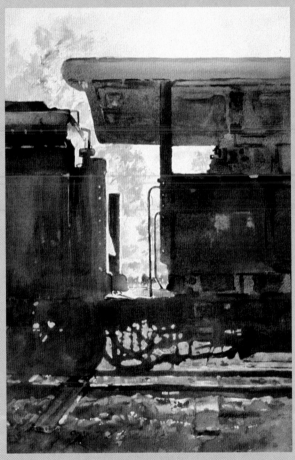

HENRY W. DIXON
NIGHT VISION
14.75" x 22" (37.5 cm x 55.9 cm)
Arches 150 lb.

JOHN R. HOLLINGSWORTH, N.W.S.
AGE SHADOWS
30.5" x 22" (77.5 cm x 55.9 cm)
Arches 300 lb. rough

DEE WESCOTT
CONNECTED
19.5" x 13.5" (49.5 cm x 34.3 cm)
Arches 300 lb. cold press

GARY AKERS

SUNLIT RETREAT

20" x 28" (50.8 cm x 71.1 cm)

Strathmore 500 Series bristol 2-ply

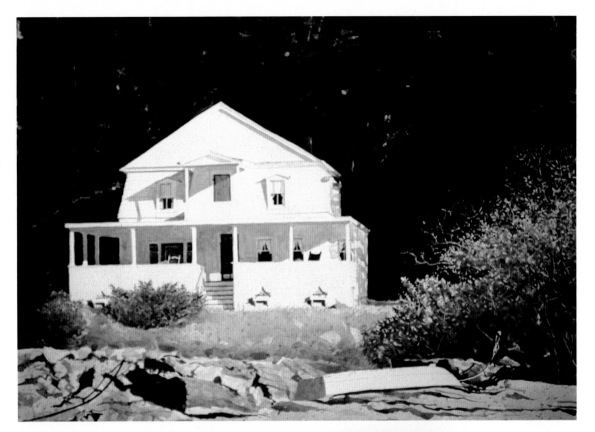

KUO YEN NG

BAY WINDOW

29" x 21" (73.7 cm x 53.3 cm)

Arches 300 lb. cold press

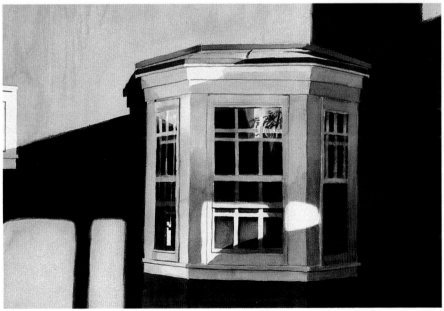

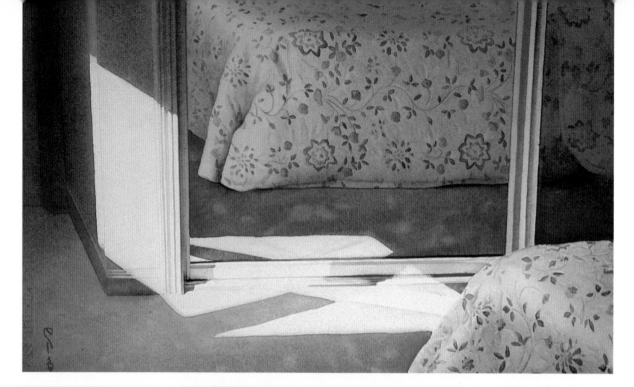

NORIKO HASEGAWA

MIRRORED DOORS

15" x 22" (38.1 cm x 55.9 cm)

Waterford 300 lb. cold press

MARY LOU METCALF

OLD BUT ELEGANT

29" x 21" (73.7 cm x 53.3 cm)

Arches 300 lb. cold press

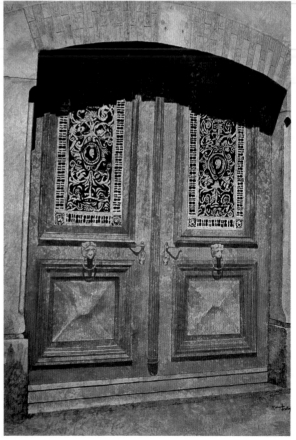

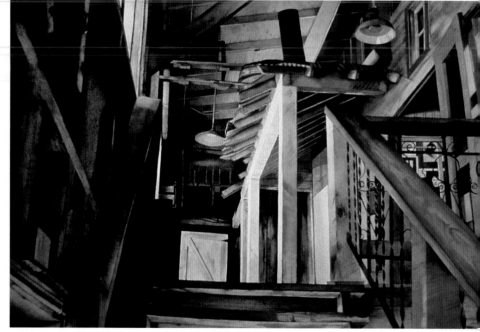

PHYLLIS SOLCYK

STEINBECK'S SCENERY

30" x 40" (76.2 cm x 101.6 cm)

Arches 140 lb. cold press

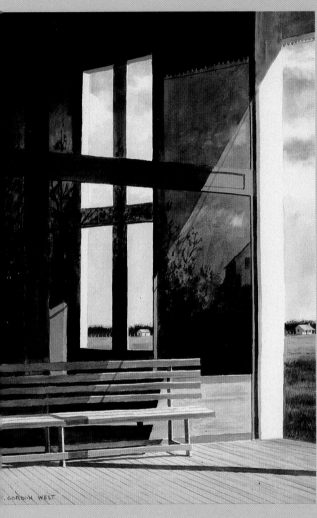

ORDON WEST, A.W.S.
R GRUENE
30" (55.9 cm x 76.2 cm)
s 300 lb. cold press

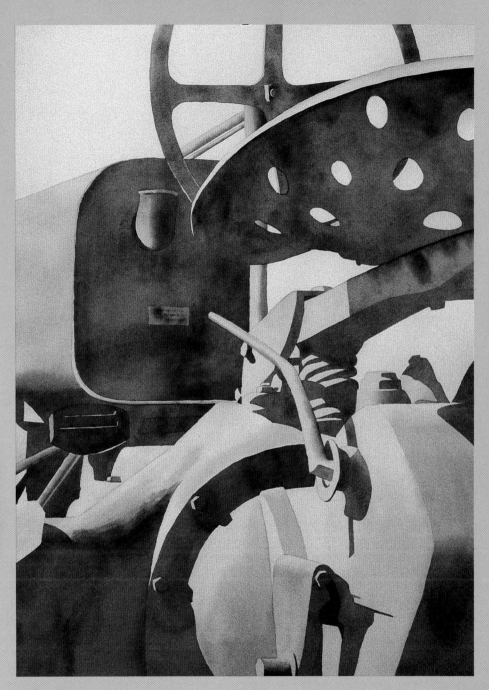

JOHN SALCHAK
TRACTOR
29" x 21" (73.7 cm x 53.3 cm)
Magnani Acquaforti 140 lb. cold press

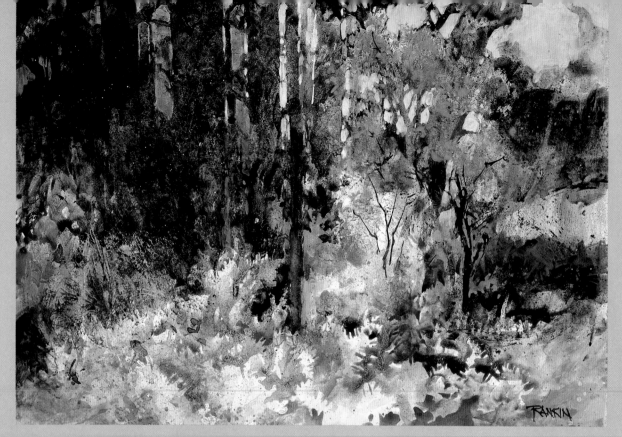

NANCY RANKIN
OLYMPIC RAIN FOREST
15" x 18" (38.1 cm x 45.7 cm)
Strathmore 500 Series
Media: Watercolor, interference
gold, gesso

**MARGARET HUDDY,
N.W.S.**
SYCAMORE, EARLY LIGHT
60" x 40" (55.9 cm x 71.1 cm)
Arches medium

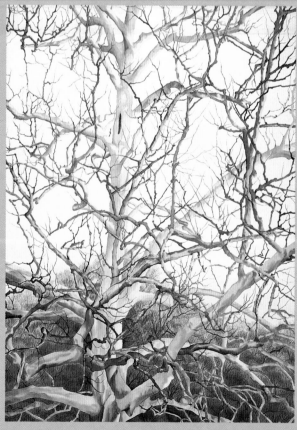

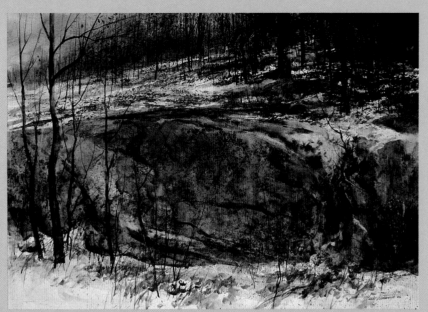

**MURRAY WENTWORTH,
N.A., A.W.S.**
WINTERED RIDGE
23" x 33" (58.4 cm x 83.8 cm)
Strathmore medium surface

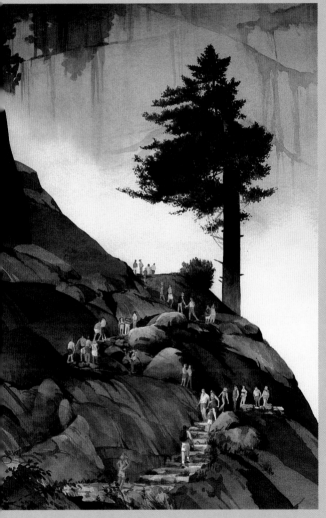

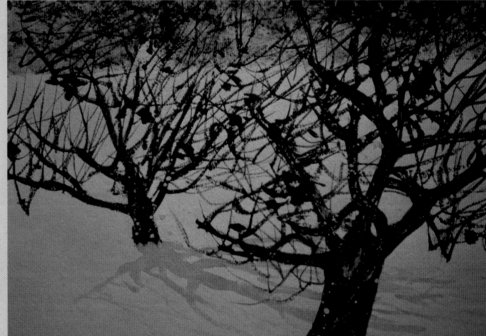

HOWARD HUIZING
MIST TRAIL
36" x 18" (91.5 cm x 71.1 cm)
Arches 140 lb. cold press

BENJAMIN MAU, N.W.S.
HEDGE APPLES
24" x 30" (60.9 cm x 76.2 cm)
Arches 140 lb. cold press

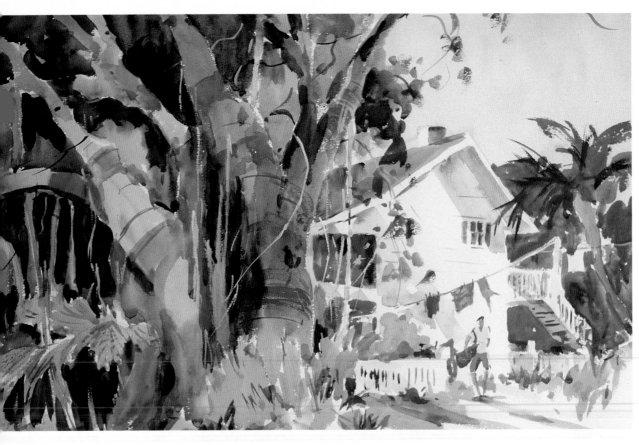

PETER L. SPATARO
BANYAN PARADISE
22" x 30" (55.9 cm x 76.2 cm)
Waterford 140 lb. cold press
Media: Gouache

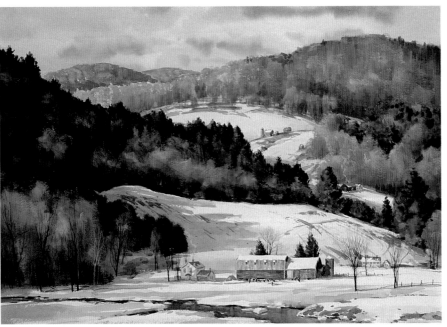

DONALD A. MOSHER
OUTSIDE WOODSTOCK
22" x 30" (55.9 cm x 76.2 cm)
Arches 300 lb.

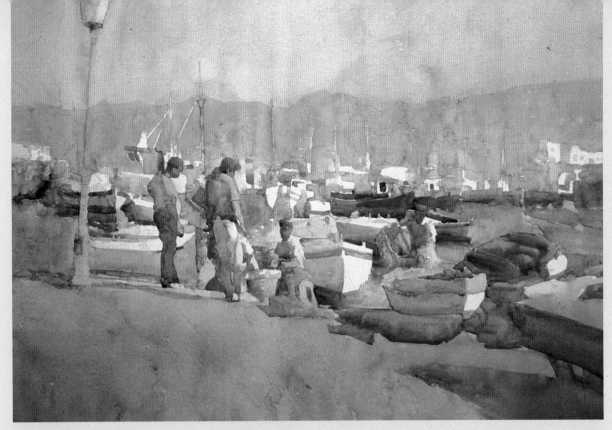

**ANNE ADAMS
ROBERTSON MASSIE**
MYKONOS HARBOR III
28" x 36" (71.1 cm x 91.4 cm)
Fabriano Artistico 140 lb. cold press

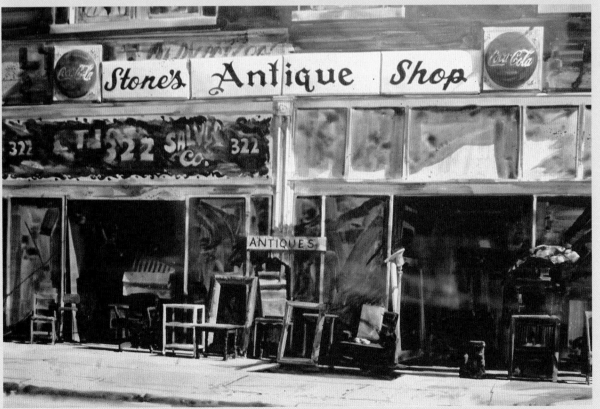

MARVIN YATES
STONE'S ANTIQUE SHOP
20" x 28" (50.8 cm x 71.1 cm)
Strathmore Hyplate

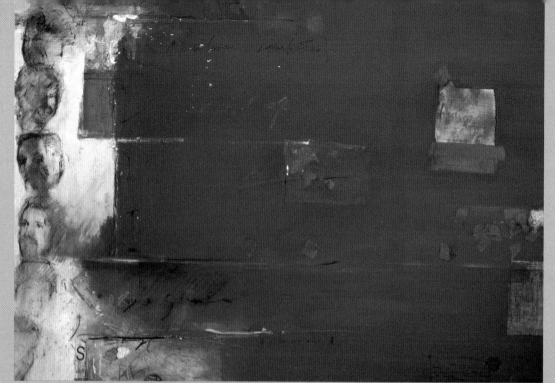

ALEX POWERS
ART BUDDIES
30" x 40" (76.2 cm x 101.6 cm)
Strathmore
Media: Gouache, charcoal collage,
pastel, watercolor

BARBARA BURWEN
KIYO
30" x 22" (76.2 cm x 55.9 cm)
140 lb. hot press
Media: Watercolor, charcoal pow-
der, acrylic, watercolor pencils

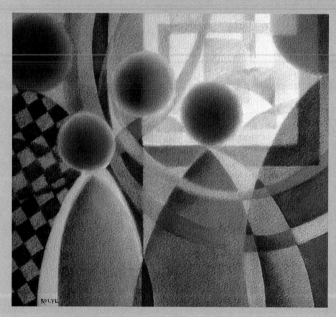

JEAN ROLFE
LOOKING AT MODERN ART
9" x 10" (22.9 cm x 25.4 cm)
Arches 140 lb. rough

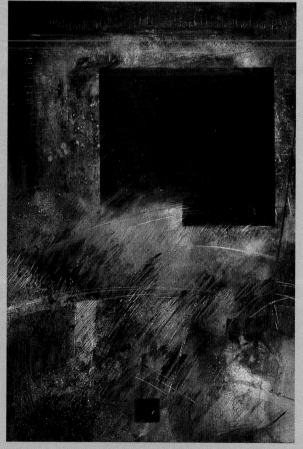

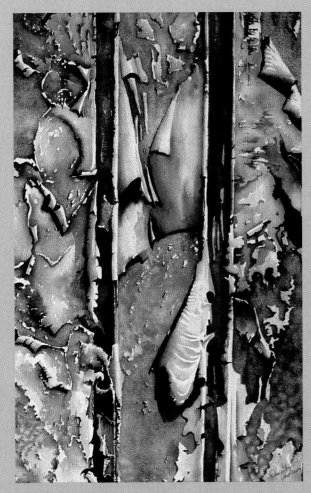

GAYLE DENINGTON-ANDERSON

STARS AND STRIPES (ALMOST) FOREVER

22" x 15" (55.9 cm x 38.1 cm)

Arches 140 lb. rough

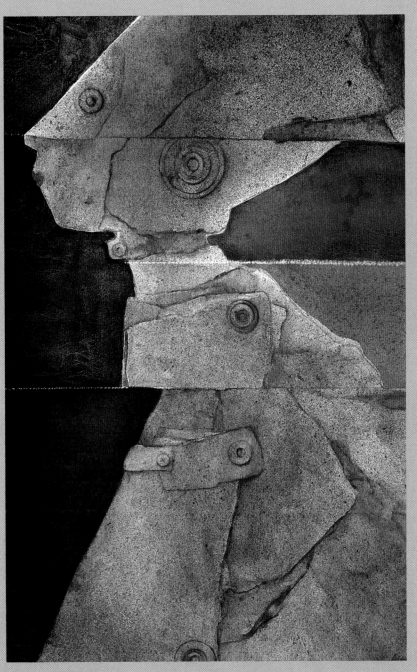

AIDA SCHNEIDER

NEFERTITI -

DECONSTRUCTED

30" x 22" (76.2 cm x 55.9 cm)

Arches 300 lb. cold press

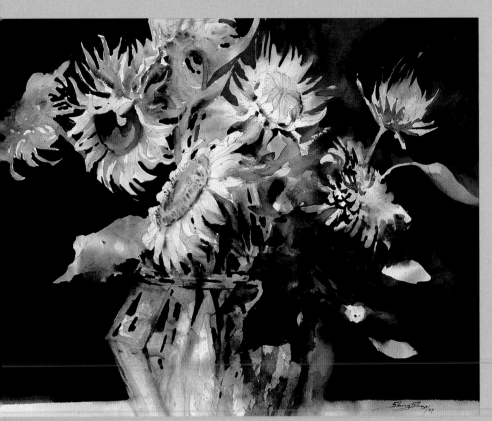

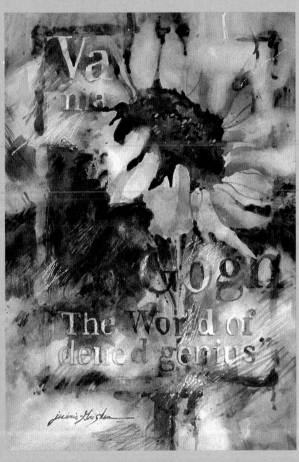

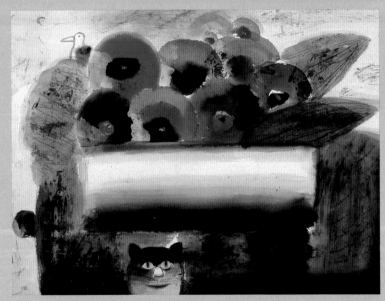

GREGORY LITINSKY, N.W.S.
CAT AND BIRD
22" x 30" (55.9 cm x 76.2 cm)
Arches 140 lb. cold press

JEANNIE GRISHAM
VAN GOGH'S INSPIRATION
21" x 14" (53.3 cm x 35.6 cm)
Lana Aquarelle 140 lb. hot press

JOYCE GOW, M.W.S.
PETALS
21" x 29" (53.3 cm x 73.7 cm)
Arches 140 lb. cold press

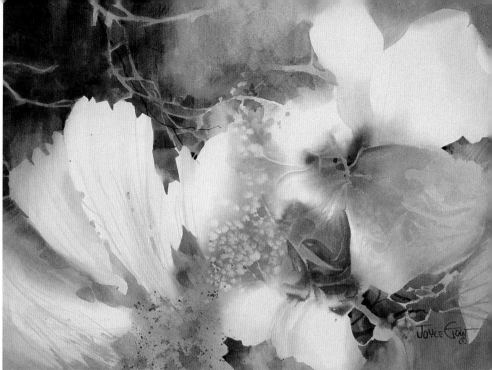

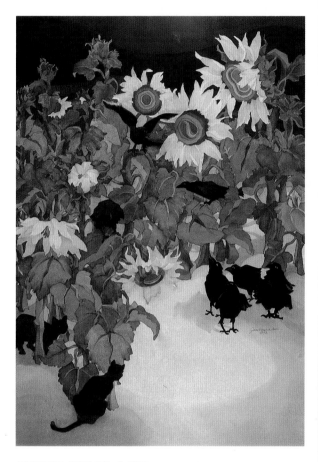

JANET B. WALSH, A.W.S.
WAITING GAME
30" x 40" (76.2 cm x 101.6 cm)
300 lb. cold press

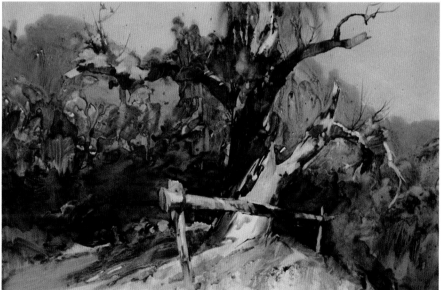

RUTH WYNN
NESTING PLACE
21" x 28" (53.3 cm x 71.1 cm)
Strathmore high surface

FRANK LALUMIA, H.W.S.

SANTUARIO (CHIMAYO, NEW MEXICO)

22" x 30" (55.9 cm x 76.2 cm)

Fabriano Esportazione 147 lb.
cold press

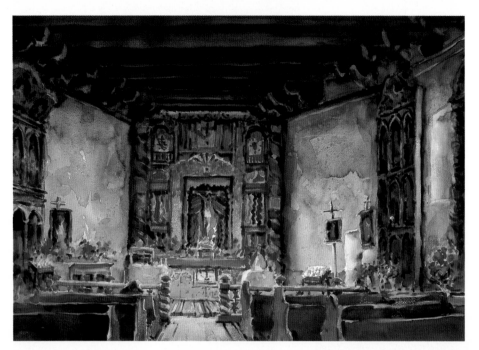

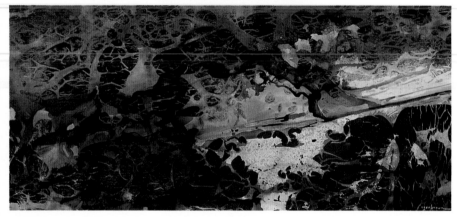

ROSE WEBER BROWN

Tropical Canopy

17.5" x 38.5" (44.5 cm x 97.8 cm)

Strathmore Hyplate

Media: Permanent inks

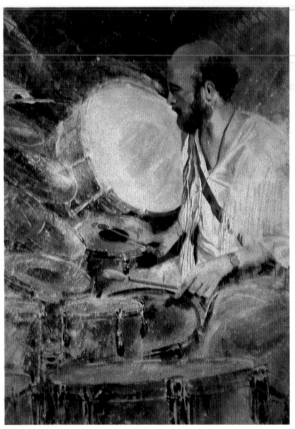

JANICE EDELMAN

SIZZLE

30" x 22" (76.2 cm x 55.9 cm

Arches 300 lb. cold press

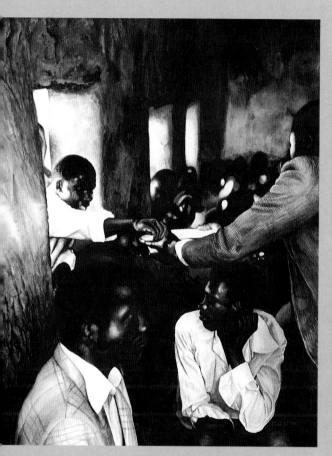

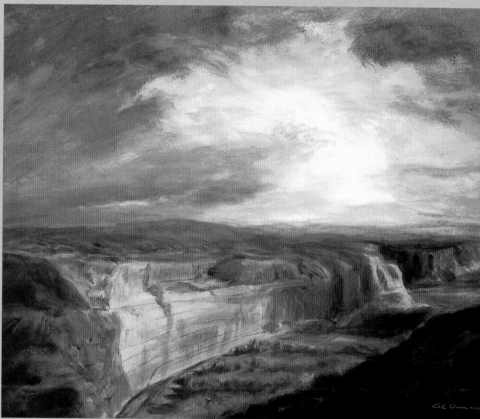

DAVID L. STICKEL

MALAWI COMMUNION

20" x 15.5" (50.8 cm x 39.4 cm)

Winsor & Newton 140 lb. hot
press

CAL DUNN, A.W.S., N.W.S.

AFTERGLOW CANYON DE CHELLY

22" x 28" (55.9 cm x 71.1 cm)

Arches medium

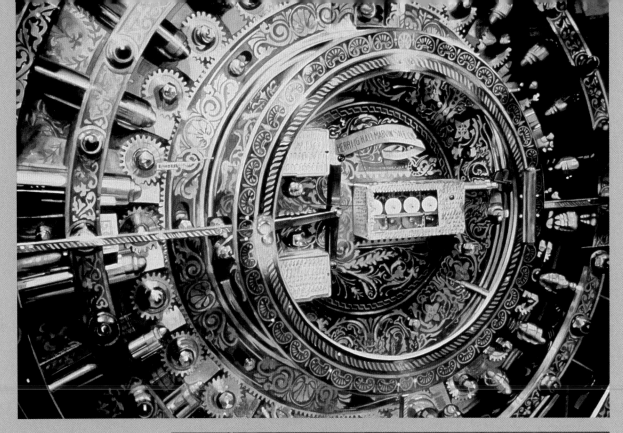

RUTH COCKLIN

THE GILDED GUARDER

32" x 46" (81.3 cm 116.8 cm)

Watercolor board

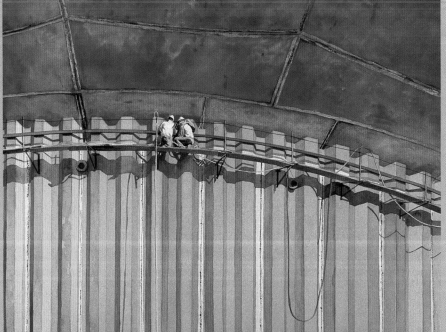

GERALDINE MCKEOWN

TANK BUILDERS

17.5" x 25" (44.5 cm x 63.5 cm)

140 lb. cold press

DONALD STOLTENBERG

OLD COLONY BRIDGE

22" x 30" (55.9 cm x 76.2 cm)

Arches 140 lb. cold press

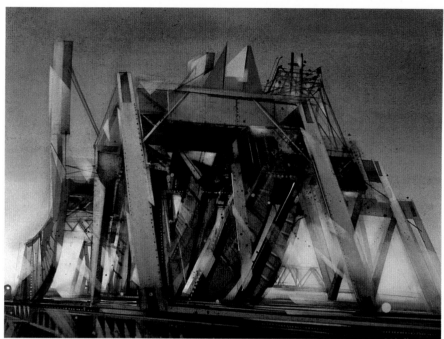

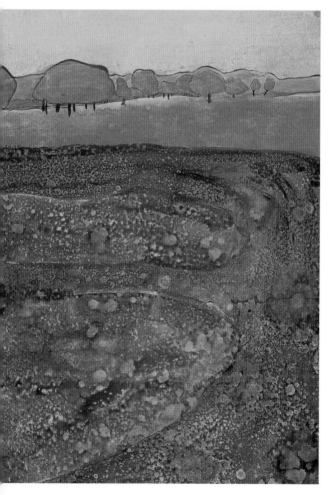

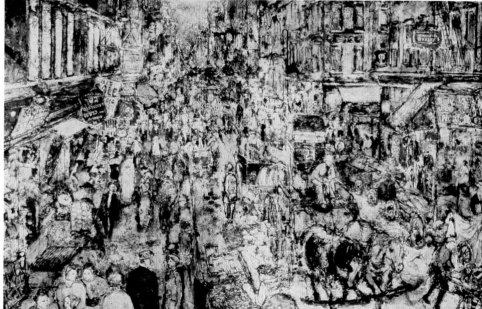

EDITH HILL SMITH,

N.W.S., S.W.S.

TEXTURED FIELDS

22" x 30" (55.9 cm x 76.2 cm)

Strathmore Aquarius II 80 lb.

Media: Acrylic, watercolor

JEROME LAND

N.Y. - 1912

38" x 26" (96.5 cm x 66 cm)

Acetate (transparent engineering paper)

Media: Casein

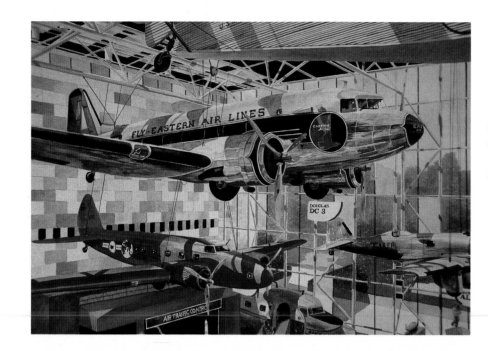

DOUG CASTELMAN

AIR AND SPACE MUSEUM

17" x 24.5" (43.2 cm x 62.2 cm)

Arches 400 lb. cold press

GREG TISDALE

SILVERDALE

17" x 27.5" (43.2 cm x 69.9 cm)

140 lb. medium surface

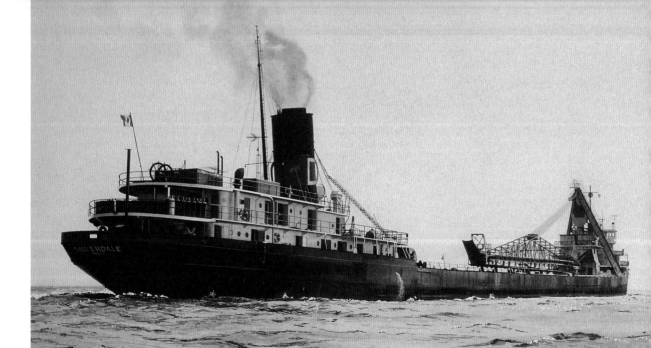

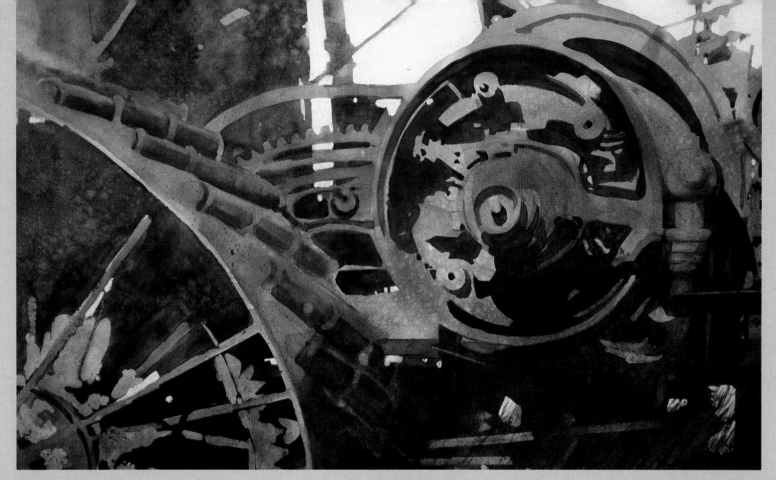

MARY BARTON
OUT OF STEAM
22" x 30" (55.9 cm x 76.2 cm)
Arches 140 lb. cold press

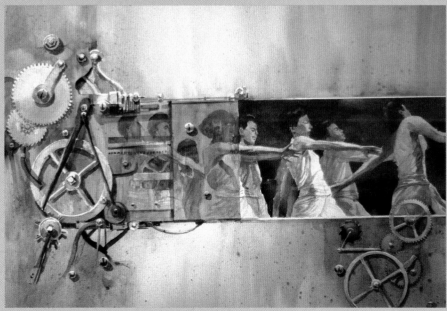

DONALD L. DODRILL,
A.W.S., N.W.S.
TIME MECHANISMS
20" x 29" (50.8 cm x 73.7 cm)
Arches 300 lb.

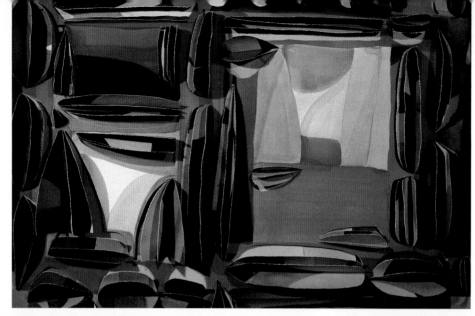

LOUISE NOBILI

SUN DOWN ORANGE

29" x 41" (73.7 cm x 104.1 cm)

Arches 555 lb. cold press

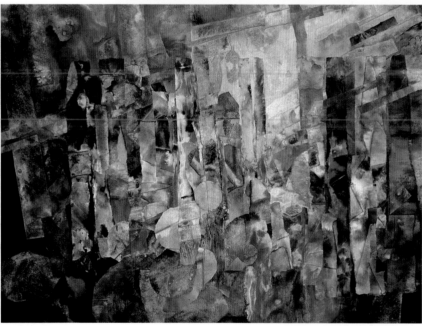

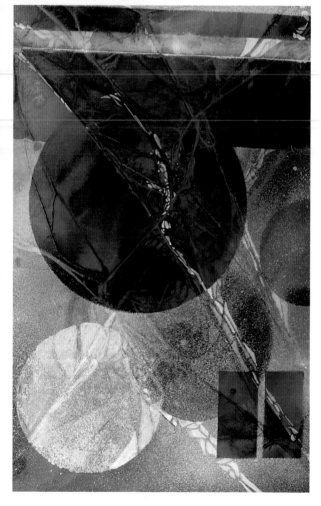

ALLAN HILL

SUSPENDED DIMENSION

22.5" x 30" (57.1 cm x 76.2 cm)

Arches 140 lb.

MARY ANN BECKWITH

ORIGIN: DREAM CAUGHT

30" x 22" (76.2 cm x 55.9 cm)

Arches 140 lb. hot press

Media: Watermedia, ink, colored

pencil, gouache

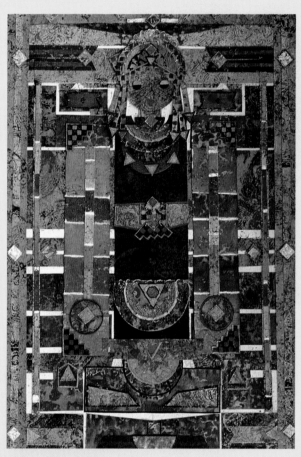

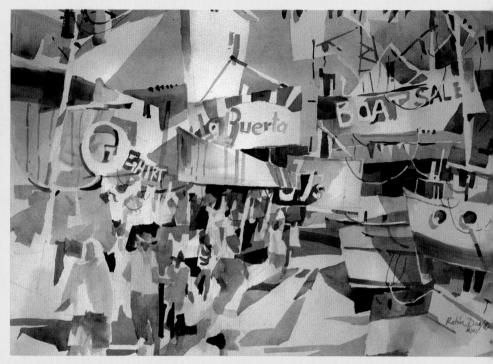

RATINDRA K. DAS,
M.W.S., N.W.W.S.
J.J.'s ETC.
20" x 30" (50.8 cm x 76.2 cm)
Arches 140 lb. cold press

BEA JAE O'BRIEN
FROM SING BURI
9.5" x 14.5" (24.1cm x 36.8 cm)
Masa rice paper
Media: Watercolor, gouache

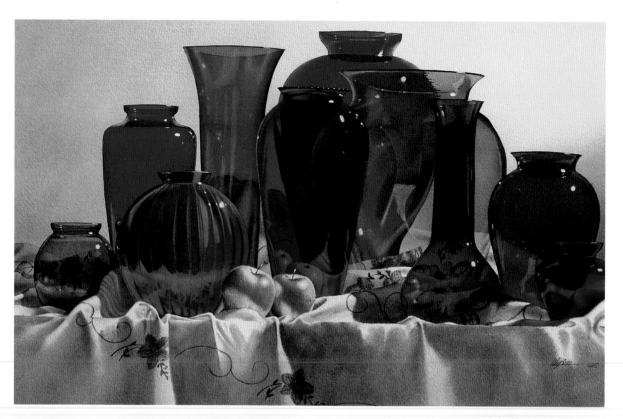

MICHAEL J. WEBER

COMPOSITION WITH
GLASS

16" x 28" (40.6 cm x 71.1 cm)

Arches 300 lb. rough

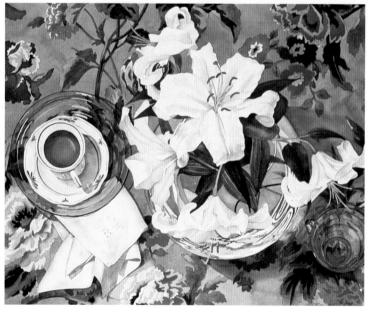

JANICE ULM SAYLES

DUTCH TILE

22" x 30" (55.9 cm x 76.2 cm)

140 lb. cold press

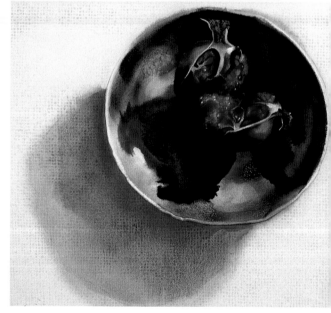

RUTH RUSH

RIPE AND READY

20" x 17" (50.8 x 43.2 cm)

Arches 300 lb. rough

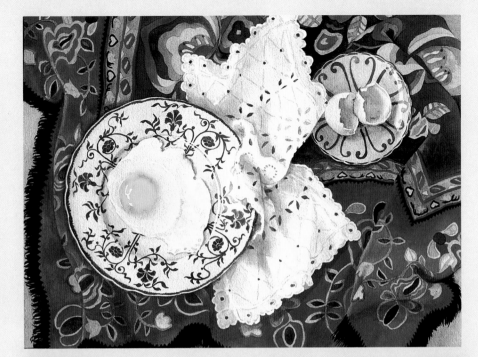

ANNE HAYES

THE BROKEN PROMISE

15" x 22" (38.1 cm x 55.9 cm)

Arches 140 lb. cold press

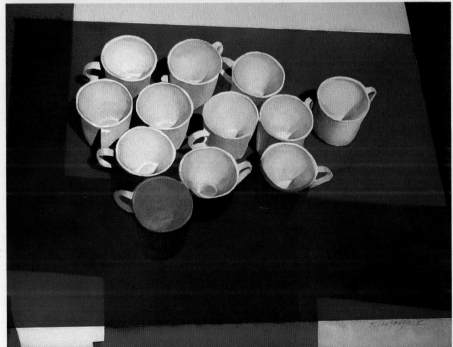

JUDITH KLAUSENSTOCK

12 WHITE CUPS

18" x 23" (45.7 cm x 58.4 cm)

Arches 140 lb. cold press

HEIDE E. PRESSE

COURTNEY'S NEW HAT

14" x 21" (35.6 cm x 53.3 cm)

Arches 300 lb. cold press

Media: Watercolor, gouache

ANN T. PIERCE

THE MIME

21.5" x 29.5" (54.6 cm x 74.9 cm)

Arches 140 lb. rough

Media: Transparent watercolor,
watercolor crayon, acrylic gel
background

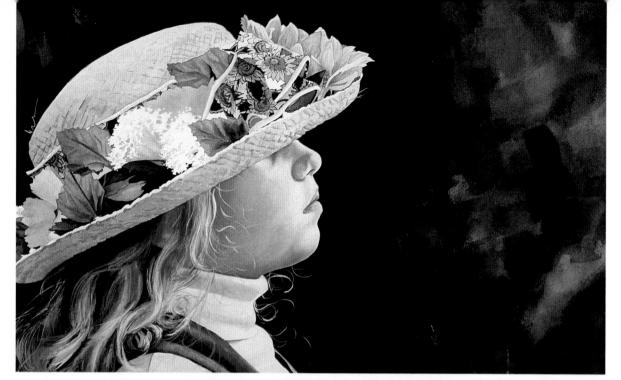

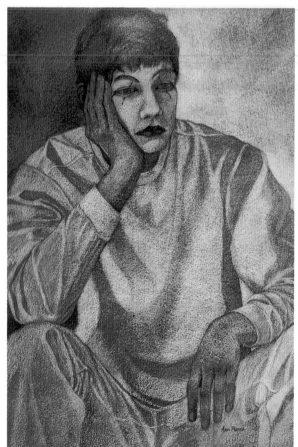

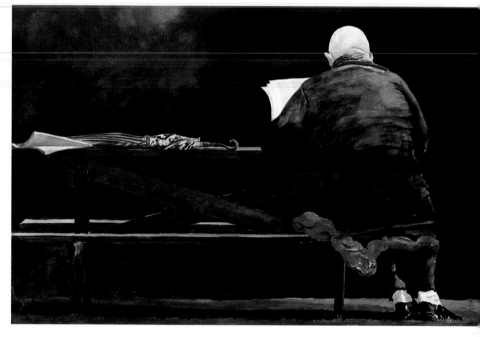

JERRY M. ELLIS, A.W.S., N.W.S.

MR. CLEAN

19" x 28" (48.3 cm x 71.1 cm)

Arches 260 lb. cold press

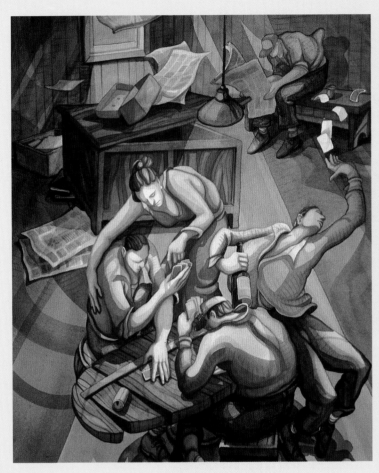

ROBERT L. BARNUM

DOWN TIME

19" x 24" (48.3 cm x 60.9 cm)

Arches 300 lb. rough

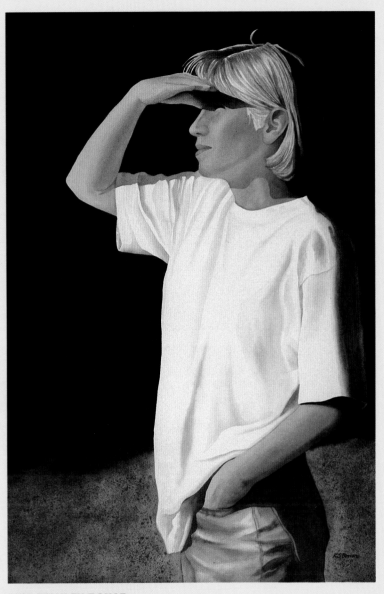

KIM STANLEY BONAR

INTO THE LIGHT

30" x 22" (76.2 cm x 55.9 cm)

Arches 300 lb. cold press

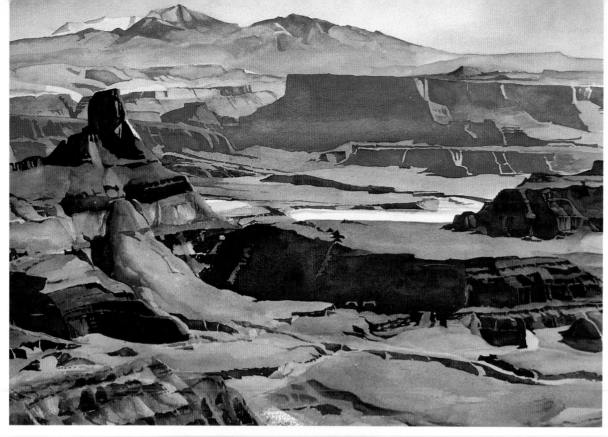

GAYLE FULWYLER SMITH

CANYON OVERLOOK
22" x 30" (55.9 cm x 76.2 cm)
E.H. Saunders 140 lb.
Media: Transparent watercolor,
glazes, wet-on-wet painting

ERIC WIEGARDT

UNIVERSITY DISTRICT
21" x 29" (53.3 cm x 73.7 cm)
Arches 260 lb. cold press

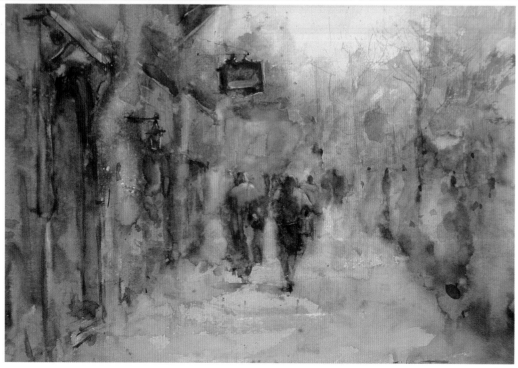

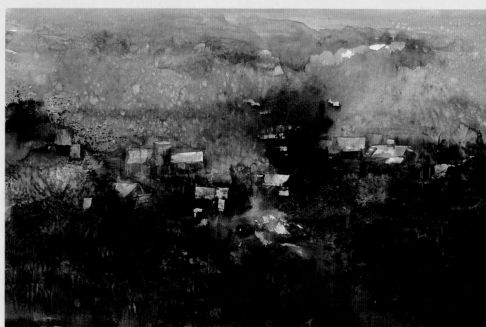

CORY STAID
VERDANT LANDSCAPE
20" x 30" (50.8 cm x 76.2 cm)
Lin-Tex

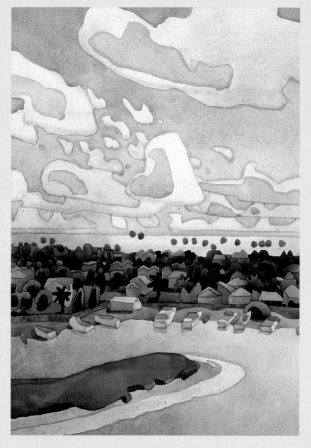

CAROLYN LORD
BRIGHT AND BREEZY:
NEWPORT BEACH
22" x 15" (55.9 cm x 38.1 cm)
Arches 140 lb. cold press

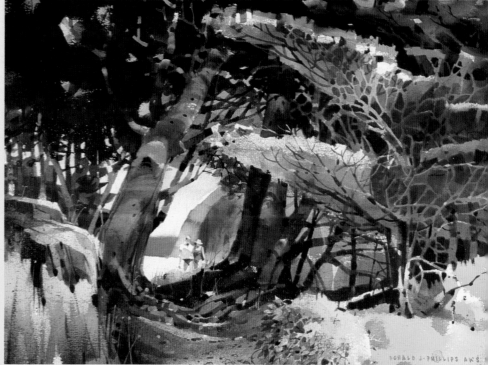

DONALD PHILLIPS
PATH TO JULIA PFEIFFER
BURNS BEACH
20" x 29" (50.8 cm x 71.1 cm)
Arches 300 lb. rough

111

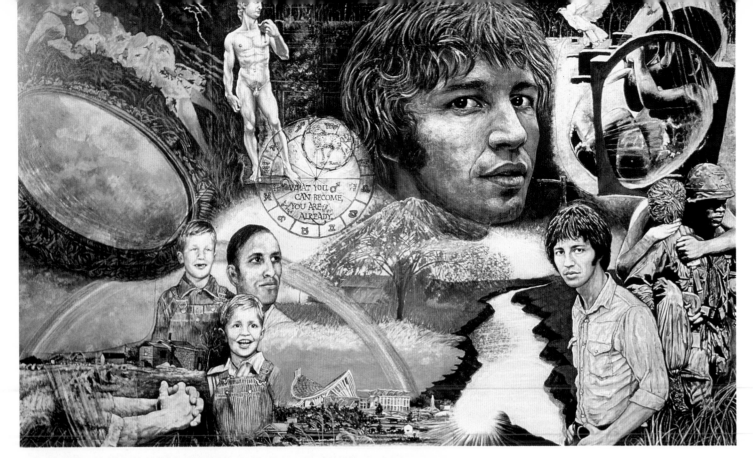

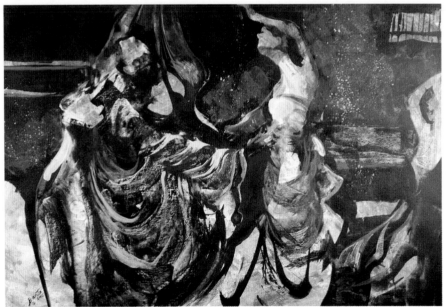

JUDITHE RANDALL

PORTRAIT OF A LIFE

18" x 28" (45.7 cm x 71.1 cm)

Crescent

Media: Grumbacher watercolors,
Rapidograph pen and ink, white
crayon chalk

DOROTHY BARTA

FROM WHENCE IT ALL
BEGAN

21" x 29" (53.3 cm x 73.7 cm)

Arches 140 lb. cold press

Media: Acrylic, gesso

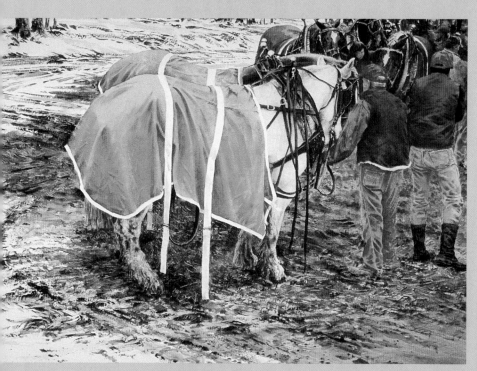

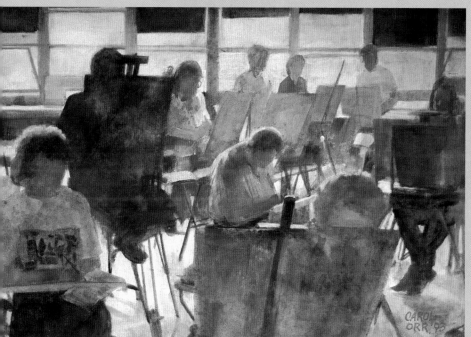

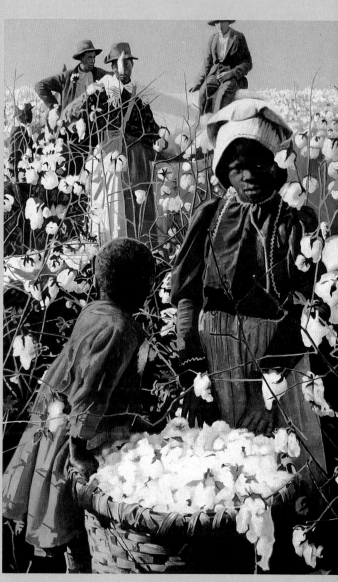

NEIL DREVITSON, A.W.S.

TEAMSTERS

22" x 30" (55.9 cm x 76.2 cm)

Waterford 300 lb. cold press

CAROL ORR, A.W.S., N.W.S.

CLASSROOM SITUATION

17" x 28" (43.2 cm x 71.1 cm)

260 lb. Winsor & Newton rough

Media: Gesso, underpainting splashes,
watercolor with gesso.

LAEL NELSON

HIGH COTTON

31" x 19" (78.7 cm x 48.3 cm)

Cold press

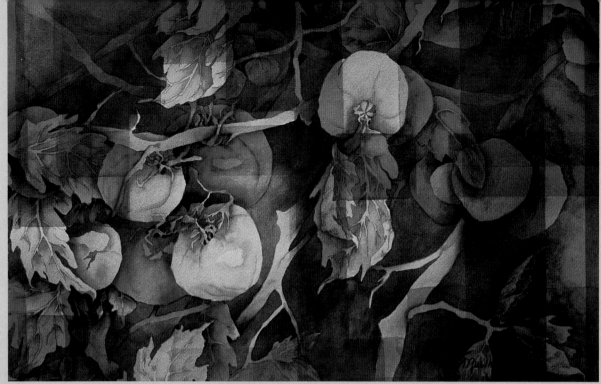

KAREN MUELLER
KESWICK
NOUVEAU TOMATOES
23" x 30" (58.4 cm x 76.2 cm)
Arches 140 lb. cold press

ANNE BAGBY
SPRING STILL LIFE
24" x 36" (60.9 cm x 91.4 cm)
Arches 140 lb. cold press
Media: Transparent watercolor,
opaque acrylic, sepia, colored pencil

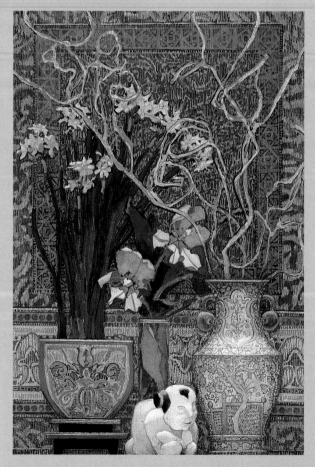

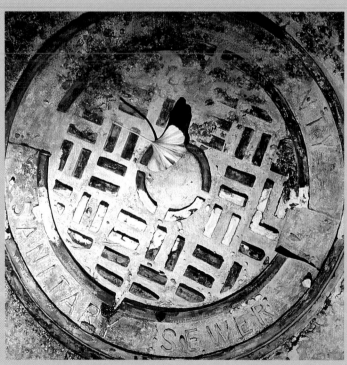

MARY LOU FERBERT
GINKGO LEAF AND MAN-HOLE COVER
28" x 28" (71.1 cm x 71.1 cm)
Tycore

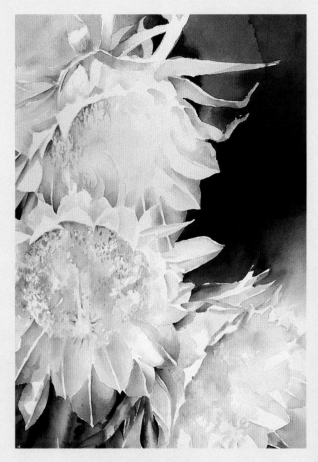

DAVID MADDERN

NIGHT BLOOMING

CEREUS VIII

40" x 32" (101.6 cm x 81.3 cm)

Lana Aquarelle 300 lb. cold press

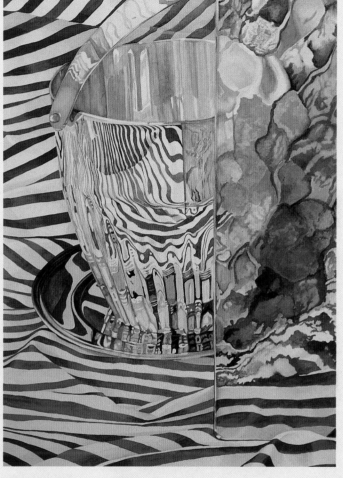

MARTHA 'MARTY' HOUSE, N.W.S.

RED STRIPES

18" x 25" (45.7 cm x 63.5 cm)

Arches 300 lb.

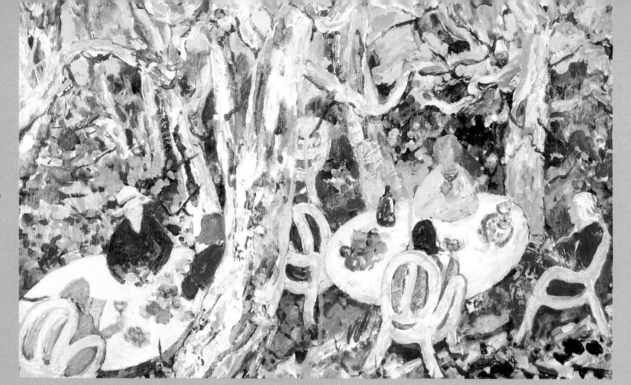

LEONA SHERWOOD

LE DÉJEUNER—

LA NAPOULE

20.5" x 27.75" (52.1 cm x 70.5 cm)

Arches 140 lb. cold press

(unstretched)

Media: Watercolor, gouache

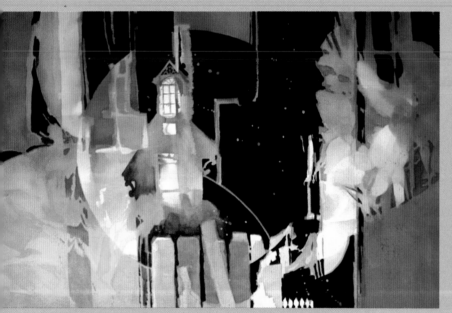

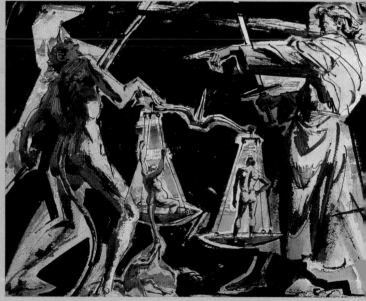

PEGGY PIPKIN

PLANET EARTH

22" x 30" (55.9 cm x 76.2 cm)

Arches 140 lb.

JOHN A. LAWN, A.W.S.

GO TO HELL

16" x 20" (40.6 cm x 50.8 cm)

Arches 140 lb.

Media: Watercolor, acrylic, diluted water, proof black ink

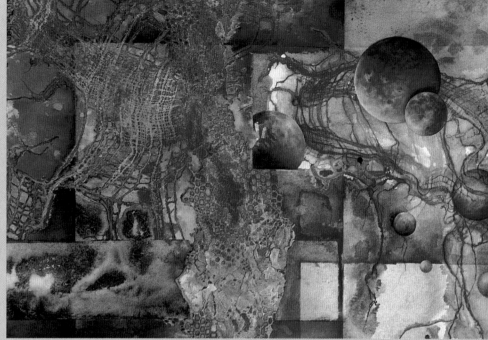

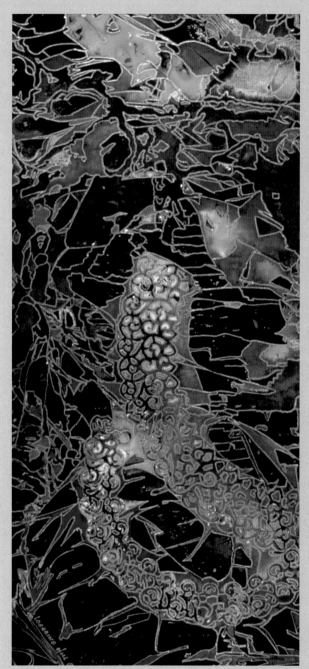

LORRAINE HILL, S.E.A.
INTRICATE PATTERNS
9" x 21" (22.9 cm x 53.3 cm)
Bainbridge
Media: Premixed ink,
watercolor, acrylic, gold pen

WILLENA JEANE BELDEN
MOMENTARY VISION
12" x 18" (30.5 cm x 45.7 cm)
140 lb. cold press

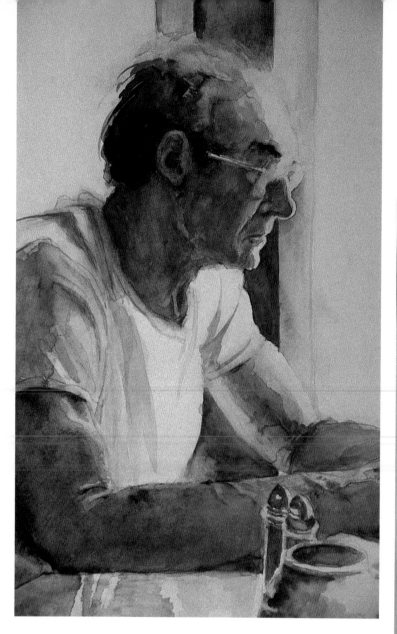

RON TIRPAK

UNTITLED

13.5" x 10" (34.3 cm x 25.4 cm)

Bristol 2-ply plate

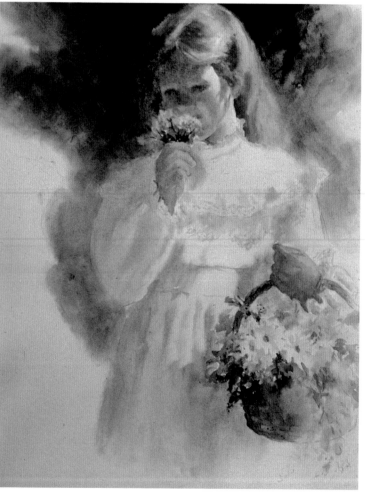

MILDRED BARTEE

SUNNY

21.25" x 28.5" (53.9 cm x 72.4 cm)

Fabriano Artistico 140 lb. smooth

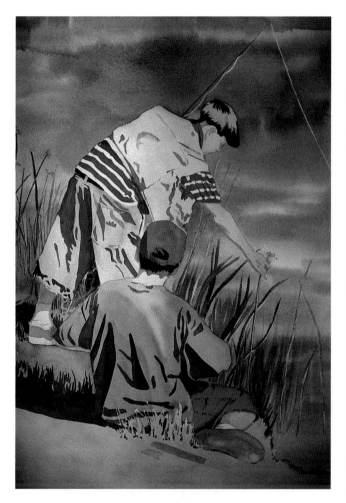

PAULA B. HUDSON

ANCIENT PASTTIMES II

22" x 33" (55.9 cm x 83.8 cm)

Lana Aquarelle 300 lb.

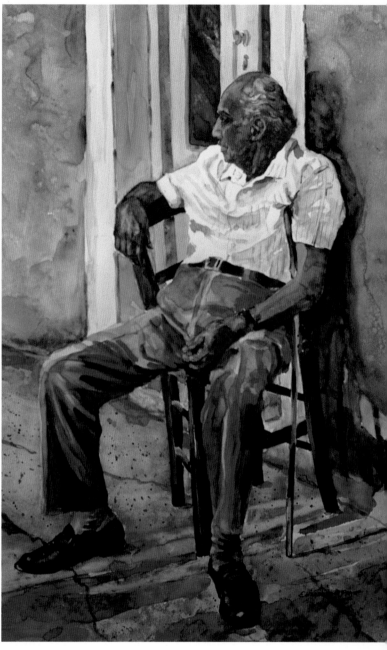

ELIZABETH H. PRATT

SUNDAY AFTERNOON

28" x 22" (71.1 cm x 55.9 cm)

Strathmore 3-ply

HILDA STUHL

ROSE & RIBBONS

22" x 30" (55.9 cm x 76.2 cm)

Arches 140 lb. cold press

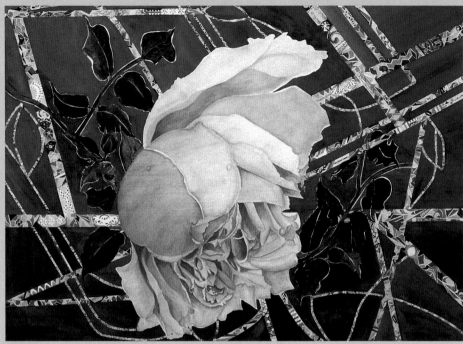

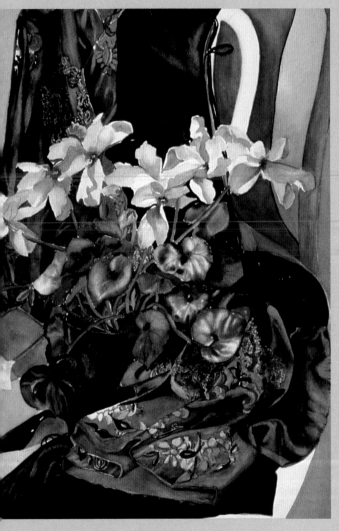

CAROLYN H. PEDERSEN, N.W.S.

ORIENTAL TREASURE

22" x 30" (55.9 cm x 76.2 cm)

Arches 300 lb. cold press

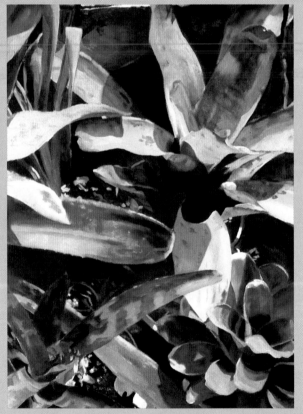

PAT BERGER

BROMELIAD MEDLEY

36" x 22" (91.4 cm x 55.9 cm)

Arches 500 lb. hot press

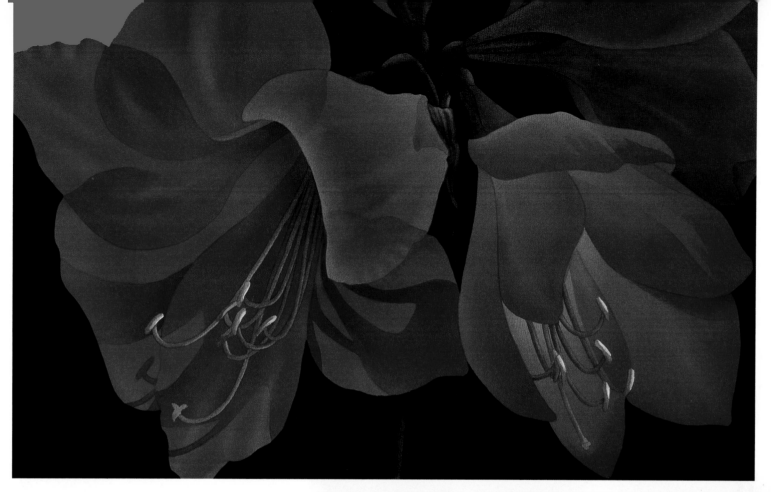

ANN SALISBURY

INNER GLOW

20" x 15" (50.8 cm x 38.1 cm)

Arches 140 lb. cold press

Media: Acrylic, watercolor,

gouache

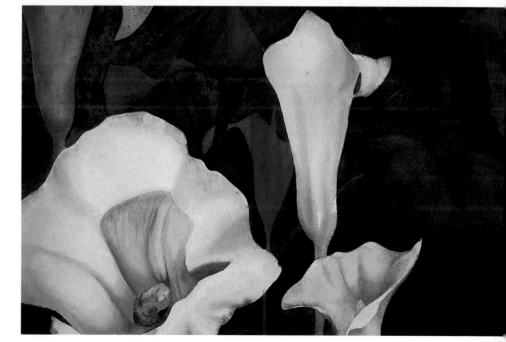

PATRICIA A. HICKS

MIDNIGHT CALLAS

15" x 22" (38.1 cm x 55.9 cm)

Arches 140 lb. cold press

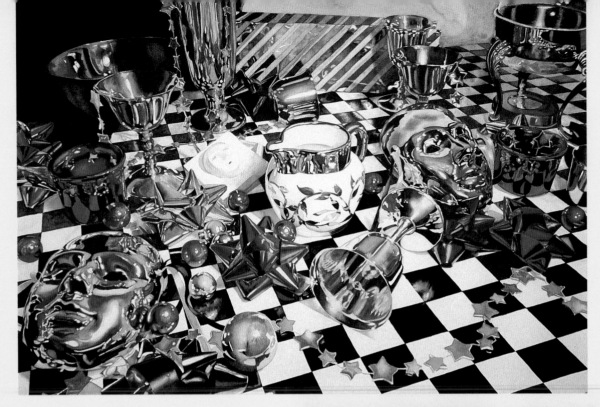

CYNTHIA PETERSON
STARS II
29.5" x 40" (74.9 cm x 101.6 cm)
Lana Aquarelle double elephant

LINDA TOMPKIN,
A.W.S., N.W.S.
HOH SQUA SA GADAH
20" x 22" (50.8 cm x 55.9 cm)
Crescent 100 lb. cold press
Media: Opaque acrylic

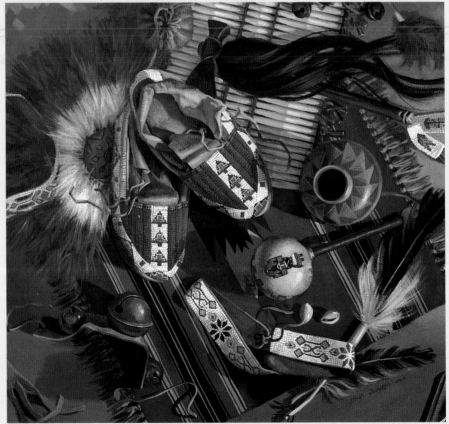

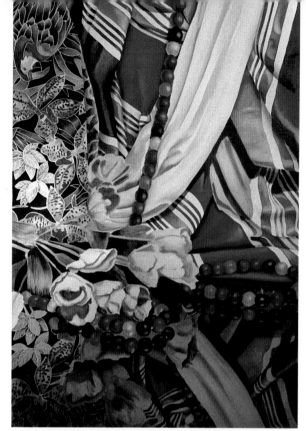

KAREN GEORGE
BEADS AND MORE
26" x 40" (66 cm x 101.6 cm)
Arches 140 lb. cold press

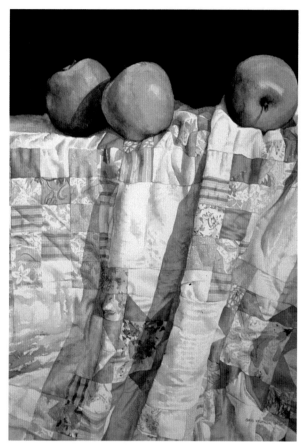

CHRIS KRUPINSKI
QUILT WITH GREEN
APPLES
22" x 30" (55.9 cm x 76.2 cm)
Arches 300 lb. cold press

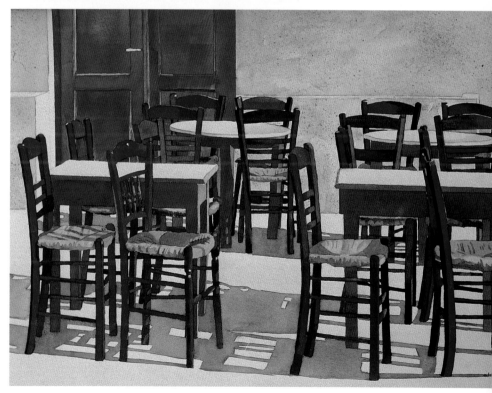

ELOISE POPE
RED HOT SEATS
22" x 30" (55.9 cm x 76.2 cm)
Arches 300 lb.

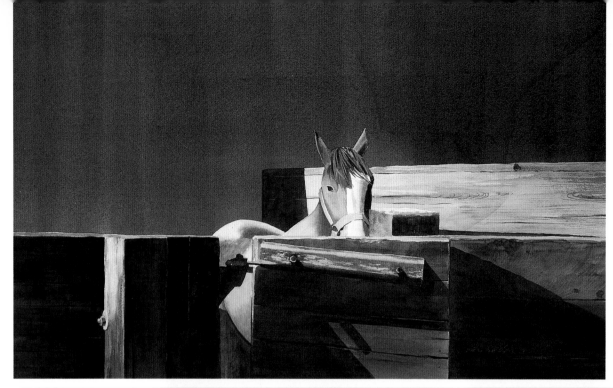

KEN HANSEN

AT THE VETS

13" x 20" (33 cm x 50.8 cm)

Arches 300 lb. cold press

KITTY WAYBRIGHT

OLD SHAY #5

29" x 21" (73.7 cm x 53.3 cm)

Fabriano Esportazione 147 lb.

REVELLE HAMILTON

CATCHING THE BREEZE

21" x 29" (53.3 cm x 73.7 cm)

Strathmore Aquarius II

Media: Acrylic

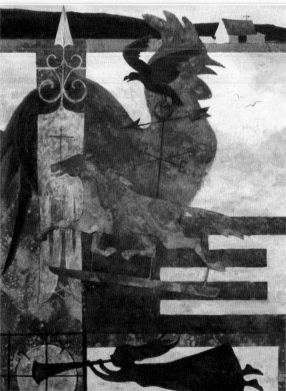

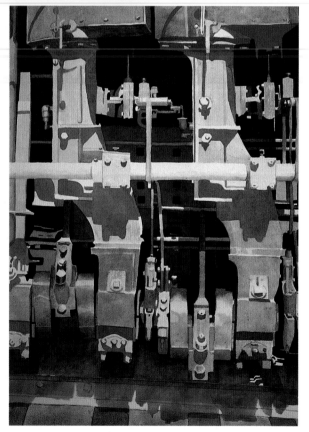

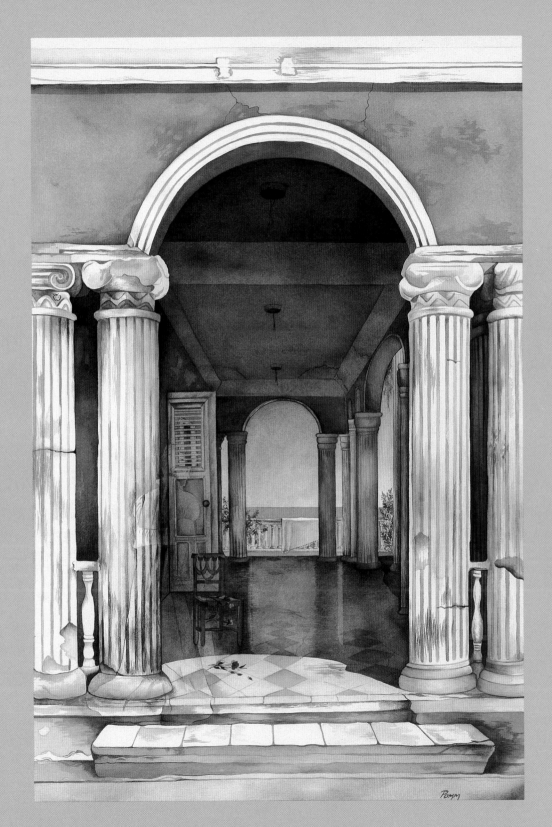

POMM

SPLENDID MEMORIES

23" x 33" (58.4 cm x 83.9 cm)

Arches 140 lb. cold press

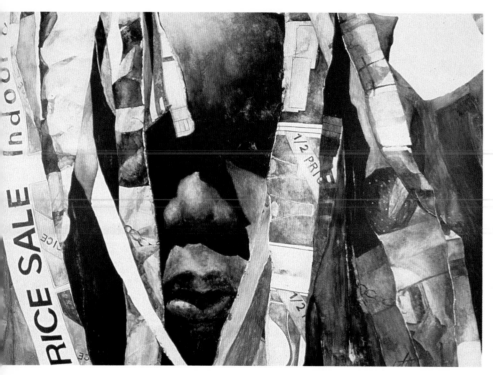

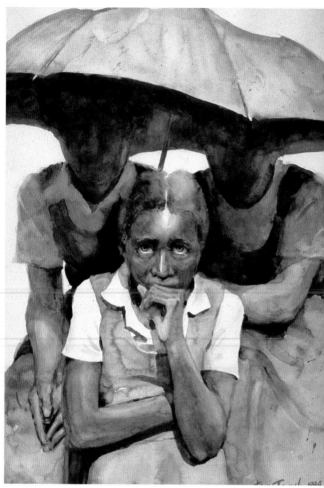

S.J. HART

NATHANIEL

40" x 60" (101.6 cm x 152.4 cm)

Foam core

THOMAS V. TRAUSCH

IN PASSING

26" x 20" (66 cm x 50.8 cm)

Arches 140 lb. hot press

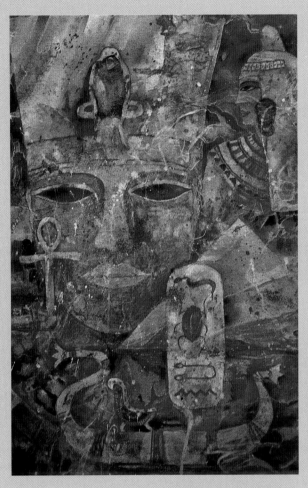

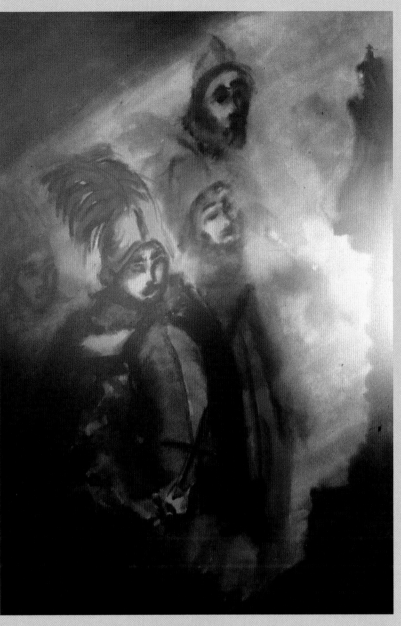

MARY UNTERBRINK
LAND OF THE PHARAOHS
13" x 18" (33 cm x 45.7 cm)
Arches 140 lb. cold press

LOIS DUITMAN
DON DIEGO DE VARGAS
18" x 24" (45.7 cm x 60.9 cm)
140 lb. cold press rough

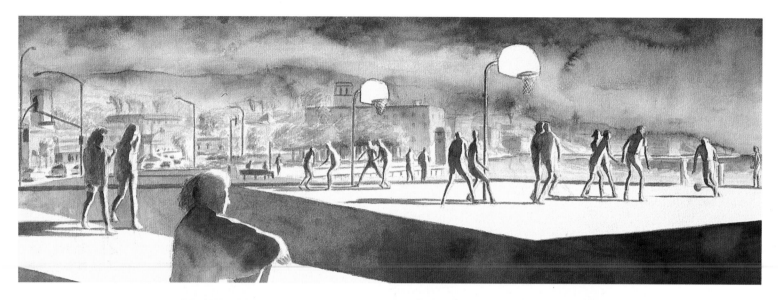

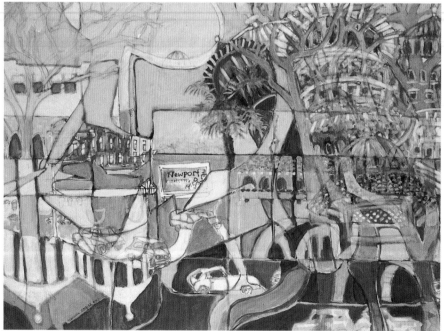

MARY T. MONGE

SHOOTING HOOPS IN
LAGUNA BEACH
30" x 11" (76.2 cm x 27.9 cm)
300 lb. cold press

MERWIN ALTFELD

GREEN HOTEL PASADENA
30" x 40" (76.2 cm x 101.6 cm)
Crescent
Media: Watercolor, acrylic

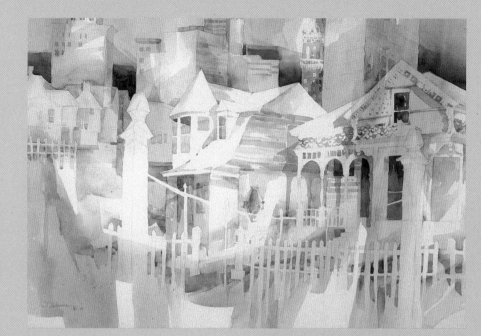

JEAN WARREN

PRESERVATION PARK

22" x 30" (55.9 cm x 76.2 cm)

Arches 140 lb. cold press

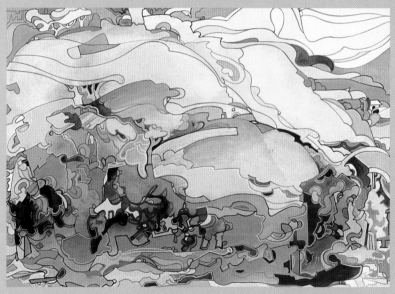

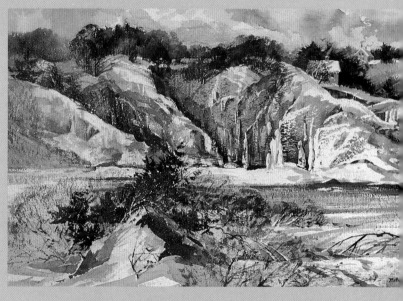

YEE WAH JUNG

COUNTRY SIDE

22" x 30" (55.9 cm x 76.2 cm)

Arches 140 lb.

Media: Watercolor and acrylic mix

NATHALIE J. NORDSTRAND, A.W.S.

WINTER AT FLAT LEDGE QUARRY

18.5" x 26" (47 cm x 66 cm)

Fabriano Esportazione 300 lb.

Media: Watercolor, gouache

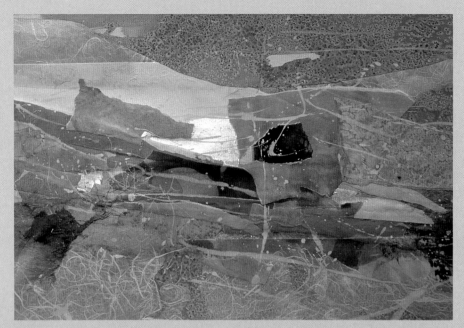

LOU RIZZOLO
CHARLEVOIX BREEZE
25.5" x 34" (64.8 cm x 86.4 cm)
Fabriano Artistico 190 lb., rice
paper

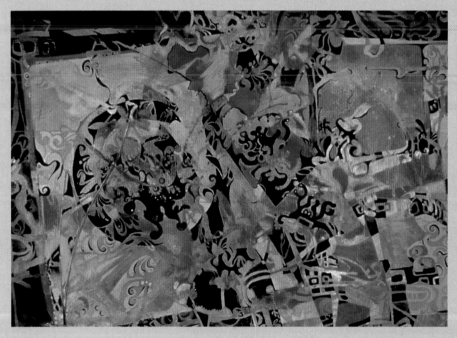

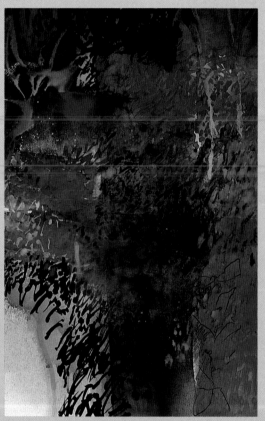

JUDI COFFEY, N.W.S.
SILK SCARF SERIES: HIDDEN TREASURERS
22" x 30" (55.9 cm x 76.2 cm)
Arches 140 lb. hot press, rice paper
Media: Collage, acrylic

PAT SAN SOUCIE
VEGETATIVE
39" x 28" (99.1 cm x 71.1 cm)
E. H. Saunders 156 lb. hot press
Media: Watercolor, gouache

MARY LIZOTTE
LEMON & LIME
21" x 28" (53.3 cm x 76.2 cm)
Lana Aquarelle 140 lb.

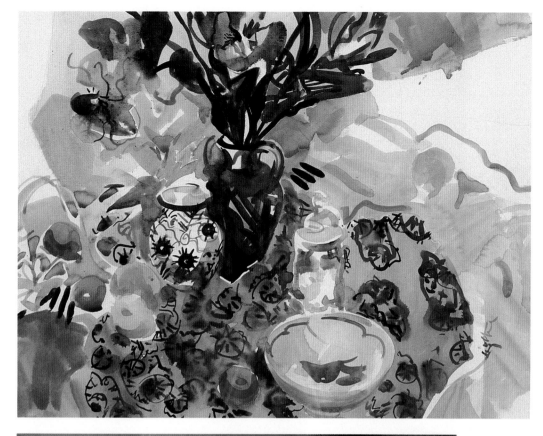

**CHENG-KHEE CHEE,
A.W.S., N.W.S.**
GOLDFISH 92 NO. 1
30" x 40" (76.2 cm x 101.6 cm)
Arches 300 lb. cold press

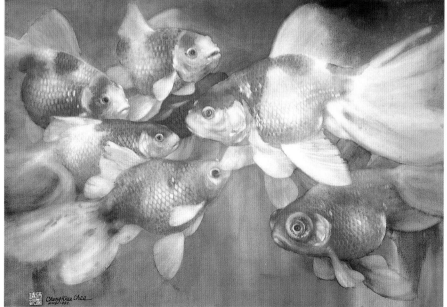

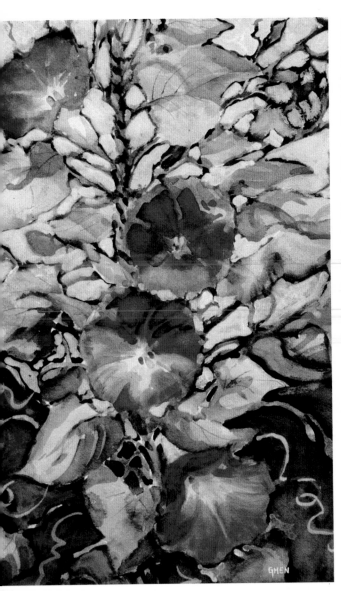

SHERRY LOEHR

VARIATION WITH LEMONS

24" x 24" (60.9 cm x 60.9 cm)

Arches 140 lb. cold press

Media: Acrylic wash, watercolor

EDYTHE SOLBERG GHEN

MORNING GLORIES

15" x 22" (38.1 cm x 55.9 cm)

Waterford 140 lb.

Media: Watercolor, gouache

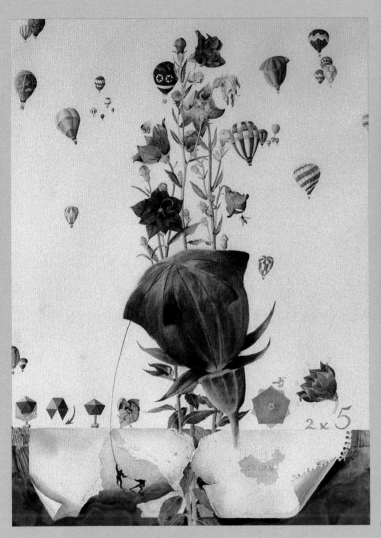

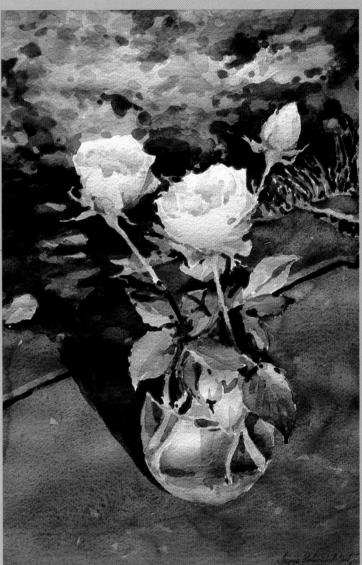

EUDOXIA WOODWARD

BALLOON FLOWER IN

FLIGHT #2

22" x 30" (55.9 cm x 76.2 cm)

Arches 140 lb. cold press

MARIJA PAVLOVICH MCCARTHY

THREE ROSES

15" x 22" (38.1 cm x 55.9 cm)

Fabriano Artistico 150 lb. rough

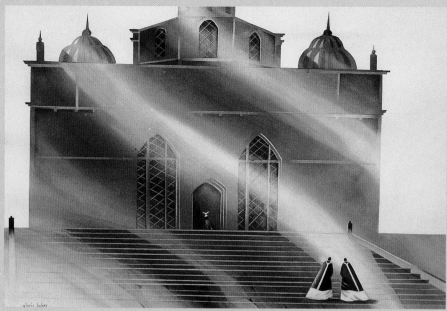

GLORIA BAKER

THE REVERANCE

29" x 21" (73.7 cm x 53.3 cm)

Arches 140 lb. cold press

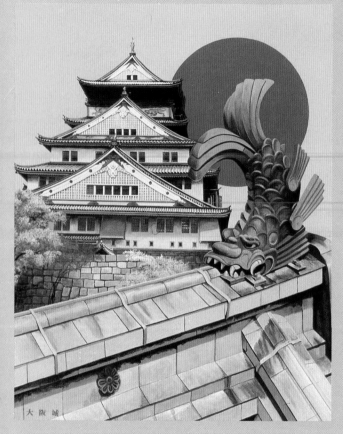

GEORGE W. KLEOPFER, JR.

OSAKA CASTLE AND FRIEND

23.75" x 29.25" (60.3 cm x 74.3 cm)

2-ply illustration board

Media: Acrylic

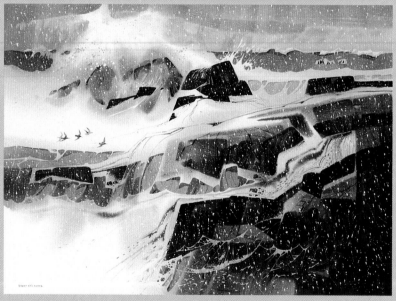

ROBERT ERIC MOORE, N.A., A.W.S.

SNOW AND WIND BIRDS

21" x 29" (53.3 cm x 73.7 cm)

Arches 140 lb. cold press

GERARD F. BROMMER

MYKONOS CHAPEL

11" x 15" (27.9 cm x 38.1 cm)

Arches 300 lb. rough

Media: Watercolor, gouache,

collage

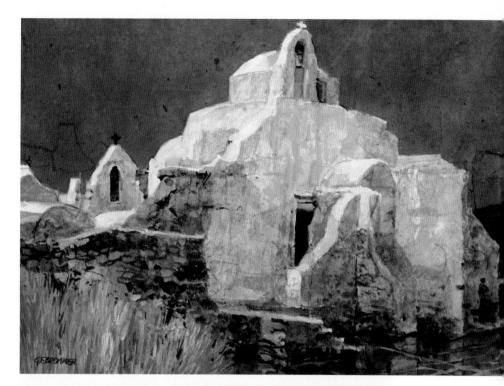

LAUREL COVINGTON-VOGL

POSTCARD FORM MILAN:

PATCHWORK PIAZZA

25" x 32" (63.5 cm x 91.4 cm)

140 lb. cold press

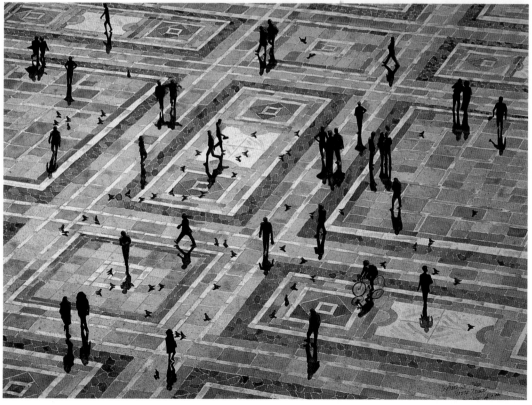

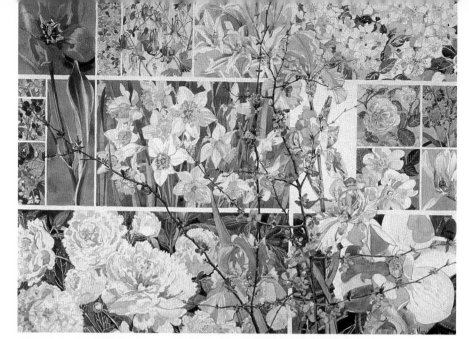

MARY FIELD NEVILLE

TENNESSEE TAPESTRY

30" x 40" (76.2 cm x 101.6 cm)

Strathmore cold press

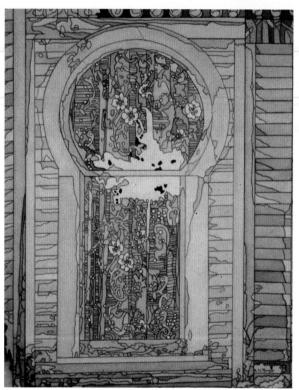

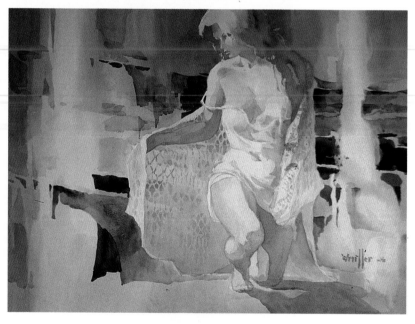

CARL VOSBURGH MILLER

PAULA

22" x 30" (55.9 cm x 76.2 cm)

Arches 140 lb. cold press

ROBERT DI MARZO

VICTORIAN LACE WINDOW

16.25" x 19.5" (41.2 cm x 49.5 cm)

140 lb. cold press

HERB RATHER, A.W.S., N.W.S.

SULLIVAN STYLE

22" x 30" (55.9 cm x 76.2 cm)

Arches 140 lb. rough

DAN BURT, A.W.S., N.W.S.

CALLEJON II

30" x 22" (76.2 cm x 55.9 cm)

Arches 300 lb. cold press

INCHA LEE

DEEP IN THE WOODS

22" x 30" (55.9 cm x 76.2 cm)

Arches 140 lb. hot press

Media: Ink

DOROTHY SKLAR

LANDMARK

13.5" x 20.5" (34.3 cm x 53.1 cm)

Whatman cold press

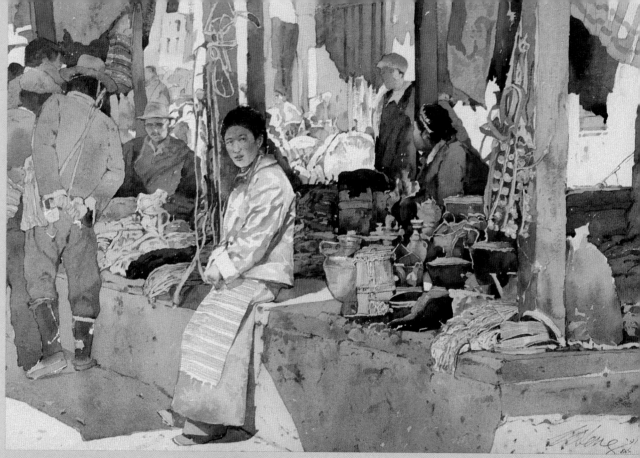

KIM SENG ONG, A.W.S.

GYANTSE MARKET

21.5" x 30" (54.6 cm x 76.2 cm)

Arches 850 G/M2 rough

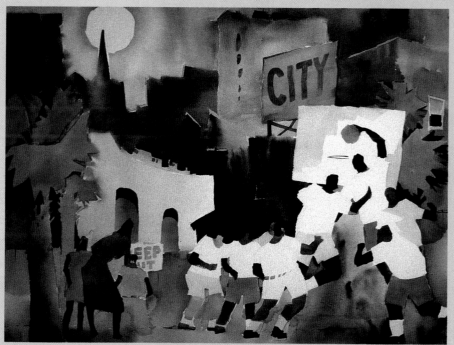

EDWIN C. SHUTTLEWORTH, M.D.

INNER CITY #3

21.5" x 29.5" (54.6 cm x 75 cm)

Arches 140 lb. cold press

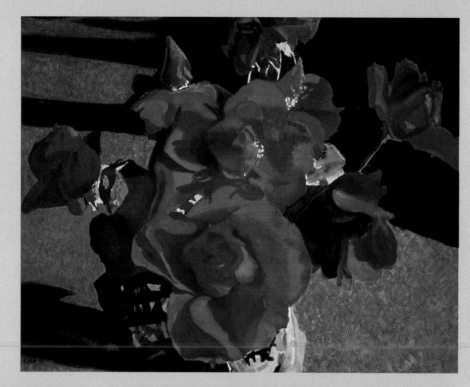

**WILLIAM VASILY
SINGELIS**
RED ROSES
34" x 39" (86.4 cm x 99.1 cm)
Illustration board

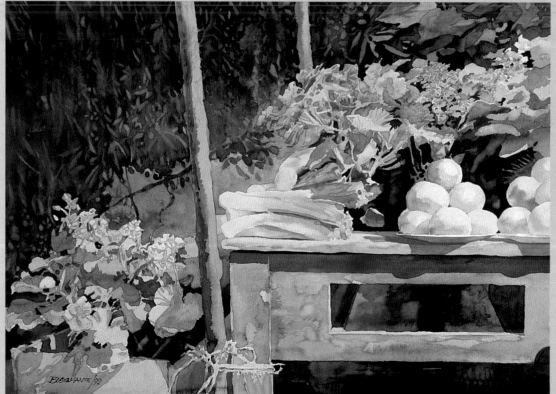

JORGE BUSTAMANTE
SURVIVORS
28" x 20" (71.1 cm x 50.8 cm)
Guarro 140 lb

ABOUT THE JUDGES

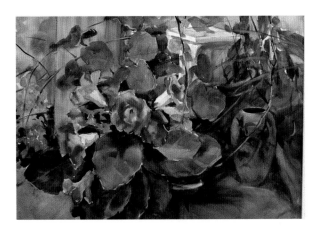

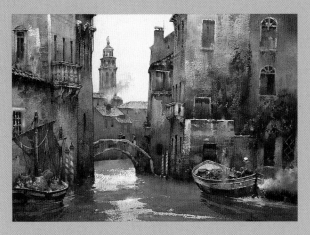

BETTY LOU SCHLEMM, A.W.S., D.F., has been painting for more than thirty years. Elected to the American Watercolor Society in 1964, and later elected to the Dolphin Fellowship, she has served as both regional vice-president and director of the American Watercolor Society. Ms. Schlemm is also a teacher and an author. Her painting workshops in Rockport, Massachusetts have become reknowned during the past twenty-seven years. Her book, *Painting with Light*, published by Watson-Guptill in 1978, has remained a classic. Her techniques have recently been featured in *Learn to Watercolor the Edgar Whitney Way*, a new publication from North Light.

TOM NICHOLAS, N.A., A.W.S., D.F., has maintained a gallery, home, and studio in Rockport, Massachusetts since 1982. His work is represented in a dozen museum collections, including the Butler Institute of American Art in Ohio, the Farnsworth Museum in Maine, the Springfield Art Museum in Missouri, and the Peabody Museum in Massachusetts. An award-winning artist, Nicholas' work has been featured in more than 35 one-man shows across the United States.

Martin R. Ahearn
102 Marmion Way
Rockport, MA 01966

Gary Akers
P.O. Box 200
Spruce Head, ME 04859

Merwin Altfeld
18426 Wakecrest Drive
Malibu, CA 90265

Mary Ellen Andren
8206 B. Willowbrook Circle
S.E.
Huntsville, AL 35802-3336

Anne Bagby
242 Shadowbrook
Winchester, TN 37398

Hella Bailin
829 Bishop Street
Union NJ, 07083

Gloria Baker
2711 Knob Hill Drive
Evansville, IN 47711

Linda Baker
17763 148th Avenue
Spring Lake, MI 49456

Charles F. Barnard
4740 N. Kelsey Place
Stockton, CA 95207

Kathleen Barnes
2413 S. Eastern Avenue
#144
Las Vegas, NV 89104

Robert L. Barnum
9739 Calgary Drive
Stanwood, MI 49346

Dorothy Barta
3151 Chapel Downs
Dallas, TX 75229

Mildred Bartee
34 Cary Avenue
Lexington, MA 02173

Mary Barton
P.O. Box 23133
Waco, TX 76702-3133

Miles G. Batt Sr.
301 Riverland Road
Fort Lauderdale, FL 33312

Mary Ann Beckwith
619 Lake Avenue
Hancock, MI 49930

Sandra E. Beebe
239 Mira Mar Avenue
Long Beach, CA 90803

Willena Jeane Belden
2059 Rambler Road
Lexington, KY 40503

Henry Bell
150 N. Millcreek Road
Noblesville, IN 46060

Pat Berger
2648 Anchor Avenue
Los Angeles, CA 90064

Sabine M. Bernard
1722 S. Deleware Place
Tulsa, OK 74104-5918

Judi Betts
P.O. Box 3676
Baton Rouge, LA 70821-3676

Avie Biedinger
6158 Kaywood
Cincinnati, OH 45243

Mary Blackey
Harbor Lights C15
1032 Radcliffe Street
Bristol, PA 19007

Julian Bloom
4522 Cathy Avenue
Cypress, CA 90630-4212

Bogomir Bogdanovic
108 Park Lane
Warwick, NY 10990

Kim Stanley Bonar
9870 Van Dyke
Dallas, TX 75218

Sally Bookman
151 Manresa Drive
Aptos, CA 95003

Cecie Borschow
735 Sherwood Drive
Richardson, TX 75080-6018

Joan Boryta
133 East Main Street
Plainfield, MA 01070

Jorge Bowenforbes
P.O. Box 1821
Oakland, CA 94612

Betty M. Bowes
301 McClenaghan Mill
Road
Wynnewood, PA 19096-1012

Jane Bregoli
401 State Road
Dartmouth, MA 02747

Gerald F. Brommer
11252 Valley Spring Lane
North Hollywood, CA
91602

Al Brouillette
1300 Sunst Court
Arlington, TX 76013

Peggy Brown
1541 N. Claylick Road
Nashville, IN 47448

Rose Weber Brown
10510 Winchester Court
Fort Myers, FL 33908

Lawrence R. Brullo
1146 San Lori Lane
El Cajon, CA 92019

John Bryans
2264 N. Vernon Street
Arlington, VA 22207

Barbara Burnett
8916 Hadley Place
Shawnee Mission, MS
665212

Dan Burt
2110B West Lane
Kerrville, TX 78028-3838

Barbara Burwen
12 Holmes Road
Lexington, MA 02173

Jorge Bustamante
7730 Camino Real F407
Miami, FL 33143

Karen B. Butler
169 W. Norwalk Road
Norwalk, CT 06850

Pat Cairns
4895 El Verano
Atascadero, CA 93422

Doug Castleman
14629 Hilltree Road
Santa Monica, CA 90402-1009

Deborah L. Chabran
28 Spooner Hill Road
South Kent, CT 06785

Linda J. Chapman
Route 2 Box J
Jane Lew, WV 26378

Marge Chavooshian
222 Morningside Drive
Trenton, NJ 08618

Cheng-Khee Chee
1508 VermilionRoad
Duluth, MN 55812

Celia Clark
RD #2, Box 228A
Delhi, NY 13753

Ruth Cobb
38 Devon Road
Newton, MA 02159

Ruth Cocklin
5923 S. Willow Way
Englewood, CO 80111

Judi Coffey
10602 Cypresswood Drive
Houston, TX 77070

Loring W. Coleman
39 Poor Farm Road
Harvard, MA 01451

Joseph J. Correale Jr.
25 Dock Square
Rockport, MA 01966

Laurel Covington-Vogel
333 N.E. Circle
Durango, CO 81301

Maxine Custer
2083 Trevino Avenue
Oceanside, CA 92056

Dorothy B. Dallas
378 Eastwood Court
Englewood, NJ 07631

Mickey Daniels
4010 E. San Juan Avenue
Phoenix, AZ 85018

Ratindra K. Das
1938 Berkshire Place
Wheaton, IL 60187

Pat Deadman
105 Townhouse Lane
Corpus Christi, TX 78412

Gayle Denington-Anderson
661 South Ridge E.
Geneva, OH 44041

D. Gloria Devereaux
49 Lester Avenue
Freeport, NY 11520

Robert DiMarzo
7124 Hartwell
Dearborn, MI 48126

Henry W. Dixon
8000 E. 118th Terrace
Kansas City, MD 64134

Donald L. Dodrill
17 Aldrich Road Suite C
Columbus, OH 43214

Liz Donovan
4035 Roxmill Court
Glenwood, MD 21738

J. Everett Draper
20 Ponte Vedra Circle, P.O.
Box 12
Ponte Vedra Beach, FL
32004

Neil Drevitson
Church Hill Road, P.O. Box
515
Woodstock, VT 05091

Lois Duitman
2373 Hanover Drive
Dunedin, FL 34698

Cal Dunn
Route 9 Box 86L
Santa Fe, NM 87505

Janice Edelman
3505 Hale Road
Huntingdon Valley, PA
19006

J.A. Eiser
372 Hawthorn Court
Pittsburgh, PA 15237-2618

Jerry M. Ellis
Route 66 Studio
Route 1, Box 382
Carthage, MO 64836

Rich Ernsting
6024 Birchwood Avenue
Indianapolis, IN 46220

RenÇe Faure
600 Second Street
Neptune Beach, FL 32266

Mary Lou Ferbert
334 Parklawn Drive
Cleveland, OH 44116

Mary Field Neville
307 Brandywine Drive
Old Hickory, TN 37138-2105

Jill Figler
2230 Rising Hill Road
Placerville, CA 95667

Pat Fortunato
70 Southwick Drive
Orchard PA rk, NY 14127

Ellen Fountain
1909 N. Westridge Avenue
Tucson, AZ 85745-1557

Michael Frary
3409 Spanish Oak Drive
Austin, TX 78731

Elaine Frederickson
1602 McKeesick Lane
Stillwater, MN 55082

Jane Frey
518 W. Franklin
Taylorville, IL 62568

Karen Frey
1781 Brandon Street
Oakland, CA 94611

Gerald J. Fritzler
1051 50 Road, Box 253
Mesa, CO 81643-0253

Carolyn GrossÇ Gawarecki
7018 Vagabond Drive
Falls Church, VA 22042

Karen George
2131 Winn
Kemah, TX 77565

Edythe Solberg Ghen
42 E. Corning Street
Beverly, MA 01915

George Gibson
1449 Santa Maria Avenue
Los Osos, CA 93402

T. Thomas Gilfilen
6469 Amblewood N.W.
Canton, OH 44718

Nellie Gill
318 Madrid Drive
Universale City, TX 78148

Joyce Gow
901 11th Avenue
Two Harbors, MN 55616

Jean H. Grastorf
6049 4th Avenue N.
St. Petersburg, FL 33710

Dick Green
4617 Southmore Drive
Bloomington, MN 55437-1847

Irwin Greenberg
17 W. 67th Street
New York, NY 10023

Ellna Gregory-Goodrum
7214 Lane Park Drive
Dallas, TX 75225

Joseph E. Grey II
19100 Beverly Road
Beverly Hills, MI 48025-3901

Mary Griffin
1002 Oakwood Street
Extension
Holden, MA 01520

Jeannie Grisham
10044 Edgecombe Place
N.E.
Bainbridge Island, WA
98110

Marilyn Gross
374 MacEwen Drive
Osprey, FL 34229-9233

Carmela C. Grunwaldt
772 Linda Vista Avenue
Pasadena, CA 91103

Elaine Hahn
8823 Lake Hill Drive
Lorton, VA 22079

Becky Haletky
128 Liberty Street
Rockland, MA 02370

Revelle Hamilton
131 Mockingbird Circle
Bedford, VA 24523

Ken Hansen
241 JB Drive
Polson, MT 59860

S.J. Hart
846 Lookout Mountain
Road
Golden, CO 80401

Noriko Hasegawa
3105 Burkhart Lane
Sebastopol, CA 95472

Anne Hayes
7505 River Road #11G
Newport News, VA 23607

Janet N. Heaton
1169 Old Dixie Highway
Lake Park, FL 33403

Phyllis Hellier
2465 Pinellas Drive
Punta Gorda, FL 33983-3317

Patricia A. Hicks
506 Sheridan
Marquette, MI 49855

Sharon Hildebrand
5959 Saint Fillans Court W.
Dublin, OH 43017

Lorraine Hill
295 Gilmour Street P.H. 2
Ottawa K2P 0P7
Canada

Allan Hill
2535 Tulip Lane
Langhorne, PA 19053

Judy A. Hoiness
1840 N.W. Vicksburg
Avenue
Bend, OR 97701

John R. Hollingsworth
15426 Albright Street
Pacific Palisades, CA 90272

Martha 'Marty' House
962 N. Lakeshore Circle
Port Charlotte, FL 33952

Margaret Hoybach
101 Grayson Lane
Summerville, SC 29485

Margaret Huddy
105 N. Union Street #313
Alexandria, VA 22314

Paula B. Hudson
24364 Paragon Pl
Golden, CO 80401

Mary Sorrows Hughes
1045 Erie Street
Shreveport, LA 71106

Howard Huizing
145 S. Olive Street
Orange, CA 92666

Sandra Humphries
3503 Berkeley Place N.E.
Albuquerque, NM 87106

Bill James
15840 S.W. 79th Court
Miami, FL 33157

George James
340 Colleen
Costa Mesa, CA 92627

Philip Jamison
104 Price Street
West Chester, PA 19382

Joe Jaqua
300 Stony Point Road
Santa Rosa, CA 95401

Astrid E. Johnson
14423 Ravenswood Drive
Sun City West, AZ 85375-5629

Bruce G. Johnson
953 E. 173rd Street
South Holland, IL 60473-3529

Donal Jolley
P.O. Box 156
Rimforest, CA 92378

Carole Pyle Jones
275 Upland Road
West Grove, PA 19390

Jack Jones
391 Maple Street
Danvers, MA 01923

George W. Kleopfer Jr.
2110 Briarwood Boulevard
Arlington, TX 76013

Joyce H. Kamikura
6651 Whiteoak Drive
Richmond, BC V7E 4Z7
Canada

M.C. Kanouse
6346 Tahoe Lane S.E.
Grand Rapids, MI 49546

Karen Mueller Keswick
9707 Creek Bridge Circle
Pensacola, FL 32514-1676

Kim Seng Ong
Block 522, Hougang
Avenue 6 #10-27
Singapore 1953

Dong Kingman
21 W 58 Street
New York, NY 10019

Sandy Kinnamon
3928 New York Drive
Enon, OH 45323

Everett Raymond Kinstler
15 Gramercy Park S.
New York, NY 10003

Frances Kirsh
P.O. Box 10767
Pensacola, FL 32524

Judith Klausenstock
94 Reed Ranch Road
Tiburon, CA 94920

George Kountoupis
5523 E. 48th Place
Tulsa, OK 74135

Lynne Kroll
391771 NW 101 Drive
Coral Springs, FL 33065

Chris Krupinski
10602 Barn Swallow Court
Fairfax, VA 22032

Frederick Kubitz
12 Kenilworth Circle
Wellesley, MA 02181

Kuo Yen Ng
4514 Hollyridge Drive
San Antonio, TX 78228

Frank Lalumia
PO Box 3237 Pojoaque
Station
Santa Fe, NM 87501-0237

Jerome Land
S.W. 730 Crestview
Pullman, WA 99163

John A. Lawn
200 Hulls Highway
Southport, CT 06490

Incha Lee
713 W. Jacker Avenue
Houghton, MI 49931

Barbara Leites
18 Lehmann Drive
Rhinebeck, NY 12572

Monroe Leung
1990 Abajo Drive
Monterey Park, CA 91754

Arne Lindmark
101 Forbus Street
Poughkeepsie, NY 12603

Gregory Litinsky
253 W 91 Street #4C
New York, NY 10024

Mary Lizotte
P.O. Box 93
Norwell, MA 02061

Sherry Loehr
1580 Garst Lane
Ojai, CA 93023

Carolyn Lord
1993 De Vaca Way
Livermore, CA 94550-5609

John L. Loughlin
124 Angell Road
Lincoln, RI 02865

Mary Britten Lynch
1505 Wood Nymph Tr
Lookout Mountain, TN
37350

Betty Lynch
1500 Harvard
Midland, TX 79701

David Maddern
6492 S.W. 22nd Street
Miami, FL 33155

Joseph Manning
5745 Pine Terrace
Plantation, FL 33317

Margaret C. Manter
1328 State Road
Veazie, ME 04401

Daniel J. Marsula
2828 Castleview Drive
Pittsburgh, PA 15227

Margaret M. Martin
69 Elmwood Avenue
Buffalo, NY 14201

Ophelia B. Massey
2610 Carriage Pl
Birmingham, Al

Anne Adams Robertson
Massie
3204 Rivermont Avenue
Lynchburg, VA 24503

Karen Mathis
9400 Turnberry Drive
Potomac, MD 20854

Benjamin Mau
1 Lateer Drive
Normal, IL 61761

Marija Pavlovich McCarthy
6413 Western Avenue N.W.
Washington, DC 20015

Laurel Lake Mcguire
1914 Blueridge Rd
Ridgecrest, CA 93555

John McIver
1208 Greenway Drive
High Point, NC 27262

Geraldine McKeown
227 Gallaher Road
Elkton, MD 21921

Mark E. Mehaffey
5440 Zimmer Road
Williamston, MI48895

Paul G. Melia
3121 Atherton Road
Dayton, OH 45409

Joanna Mersereau
4290 University Avenue #14
Riverside, CA 92501

Fred L. Messersmith
726 N. Boston Avenue
Delando, FL 32724

Mary Lou Metcalf
227 Ravenhead
Houston, TX 77034-1521

Anita Meynig
6335 Brookshire Drive
Dallas, TX 75230-4017

Carl Vosburgh Miller
334 Paragon Avenue
Stockton, CA 95210

Barbara Millican
5709 Wessex
Fort Worth, TX 76133

Edward Minchin
54 Emerson Street
Rockland, MA 02370

Lance R. Miyamoto
53 Smithfield Road
Waldwick, NJ 07463

Mary T. Monge
78 Allenwood Lane
Laguna Hills, CA 92656

Robert Eric Moore
111 Cider Hill Road
York, ME 03909-5213

Judy Morris
2404 E. Main Street
Medford, OR 97504

Sybil Moschetti
1024 11th Street
Boulder, CO 80302

Donald A. Mosher
5 Atlantic Avenue
Rockport, MA 01966

Linda L. (Stevens) Moyer
9622 Zetland Drive
Huntington Beach, CA
92646

Jean Munro
7622 Simonds Road N.E.
Bothell, WA 98011-3924

Carole Myers
12870 EllsinoreDrive
Bridgeton, MO 63044

Jean R. Nelson
1381 Dow Street N.W.
Christiansburg, VA 24073

Lael Nelson
600 Lakeshore Drive
Scroggins, TX 75480

Georgia A. Newton
1032 Birch Creek Drive
Wilmington, NC 28403

Tom Nicholas
7 Wildon Hgts
Rockport, MA 01966

Beverly Nichols
1181 W. 78th Terrace
Lenexa, KS 66214

Louise Nobili
14 Donovan Place
Grosse Pointe, MI 48230

Diane Van Noord
5072 N. Lakeshore Drive
Holland, MI 49424

Nathalie J. Nordstrand
384 Franklin Street
Reading, MA 01867

Bea Jae O'Brien
34 Sea Pines
Moraga, CA 94556

Don O'Neill
3723 Tibbetts Street
Riverside, CA 92506

Robert S. Oliver
4111 E.San Miguel
Phoenix, AZ 85018

Jane Oliver
20 Park Avenue
Maplewood, NJ 07040

Carol Orr
Box 371
La Conner, WA 98257

Belle Osipow
3465 Wonderview Drive
Los Angeles, CA 90068

Doug Pasek
12405 W. Pleasant Valley
Road
Parma, OH 44130-5030

Gloria Paterson
9090 Barnstaple Lane
Jacksonville, FL 32257

Carolyn H. Pedersen
119 Birch Lane
New City, NY 10956

Ann Pember
14 Water Edge Road
Keeseville, NY 12944

Cynthia Peterson
7777 E. Heatherbrae #225
Scottsdale, AZ 85251

Donald Phillips
PROOF SAYS DON;
ENTRY FORM SAYS
DONALD
1755 49th Avenue
Capitola, CA 95010

Ann T. Pierce
545 W. Shasta Avenue
Chico, CA 95926

Peggy Pipkin
716 Grovewood Drive
Cordova, TN 38018

Carlton B. Plummer
10 Monument Hill Road
Chelmsford, MA 01824

Pomm
4865 Hartwick Street
Los Angeles, CA 90041

Eloise Pope
426 Wingrave Drive
Charlotte, NC 28270-5928

Mary Ann Pope
1705 Greenwyche Road
S.E.
Huntsville, AL 35801

Alex Powers
401 72nd Avenue N. #1
Myrtle Beach, SC 29577

Elizabeth H. Pratt
P.O. Box 238
Eastham, MA 02642

Heide E. Presse
15914 Farringham Drive
Tampa, FL 33647

Bonnie Price
2690 E. Villa Street
Pasadena, CA 91107

Judithe Randall
2170 Hollyriddge Drive
Hollywood, CA 90068

Nancy Rankin
4704 35th Street N.W.
Gig Harbor, WA 98335

Herb Rather
Route 1 Box 89
Lampasas, TX 76550

Edward Reep
8021 Crowningshield Drive
Bakersfield, CA 93311

Pat Regan
120 W. Brainard
Pensacola, FL 32501

Judith S. Rein
0064 W Greenlawn Drive
La Porte, in 46350

Ruth L. Reinel
17 W. 049 Washington
Street
Bensenville, IL 60106

Patricia Reynolds
390 Point Road
Willsboro, NY 12996

Lou Rizzolo
P.O. Box 62
Glenn, MI 49416

Jean Rolfe
P.O. Box 51
East Wilton, ME 04234

Jerry Rose
700 S.W. 31st Street
Palm City, FL 34990

Joan Ashley Rothermel
221 46th Street
Sandusky, OH 448703420

Sara Roush
2801 Coleen Court
Louisville, KY 40206

Jada Rowland
438 W 116 Street reet #73
New York, NY 10027

Ruth Rush
2418 Helen Road
Fallbrook, CA 92028

Sandra Saitto
61 Carmel Lane
Feeding Hills, MA 01030

Robert G. Sakson
10 Street acey Avenue
Trenton, NJ 08618-3421

John Salchak
18220 S. Hoffman Avenue
Cerritos, CA 90703

Ann Salisbury
7300 Tanbark Way
Raleigh, NC 27615

Pat San Soucie
68 Dortmunder Drive
Manalapan, NJ 07726

Joseph Santoro
158 Lovell Road
Watertown, MA 02172

Janice Ulm Sayles
4773 Tapestry Drive
Fairfax, VA 22032

Margaret Scanlan
1501 Campbell Station
Road
Knoxville, TN 37932

J. Luray Schaffner
14727 Chermoore Drive
Chesterfield, MO 63017-
7901

Betty Lou Schlem
19 Caleb's Lane
Rockport, MA 01966

Michael Schlicting
3465 N.E. Davis Street
Portland, OR 97232

Aida Schneider
31084 East Sunset Drive N.
Redlands, CA 92373

Carol Ann Schrader
113 East Harbor Drive
Hendersonville, TN 37075-
3400

Ruth Hickok Schubert
2462 Senate Way
Medford, OR 97504

Marie Shell
724 Natures Hammock
Road W.
Jcksonville, FL 32259

Leona Sherwood
615 Burtonwood Drive
Longboat Key, FL 34228

Donna Shuford
716 Water Oak Drive
Plano, TX 75025

Edwin C. Shuttleworth
3216 Chapel Hill Boulevard
Boynton Beach, FL 33432

Sherry Silvers
405 Shallow Brook Drive
Columbia, Sc 29223

William Vasily Singelis
25801 Lakeshore Boulevard
#132
Euclid, OH 44132-1132

Dorothy Sklar
6612 Colgate Avenue
Los Angeles, CA 90048

Gayle Fulwyler Smith
P.O. Box 56
Embudo, NM 87531

Edith Hill Smith
6940 Polo Fields Pkwy
Cuming, GA 30130-5730

Jean Snow
4 Charlotte Drive
New Orleans, LA 70122

Phyllis Solcyk
20223 Labrador Street
Chatsworth, CA 91311

Peter L. Spataro
44 Hickory Lane
Whitinsville, MA 01588

Linda L. Spies
919 Coulter Street
Fort Collins, CO 80524

Cory Staid
P.O. Box 592A
Kennebunkport, ME 04046

Cory Staid
P.O. Box 592A
Kennebunkport, ME 04046

Colleen Newport Stevens
8386 Meadow Run Cove
Germantown, TN 38138

David L. Stickel
1201 Hatch Road
Chapel Hill, NC 27516

Donald Stoltenberg
947 Satucket Rd
Brewster, MA 02631

Don Stone
P.O. Box 305
Monhegan Island, ME
04852

Paul Strisik
123 Marmion Way
Rockport, MA 01966

Betsy Dillard Stroud
620 Street onewall Street
Lexington, VA 24450

Hilda Stuhl
10559A Lady Palm Lane
Boca Raton, FL 33498

Janet Swanson
702 N. 5th Avenue
Ann Arbor, MI 48601

Roy E. Swanson
10409 E. Watford Way
Sun Lakes, AZ 85248

Fredi Taddeucci
Route 1, Box 262
Houghton, MI 49931

Nancy Meadows Taylor
6431 E. Lake Anne Drive
Raleigh, NC 27612

Paula Temple
P.O. Box 1935
University, MS 38677

Janis Theodore
274 Beacon Street
Boston, MA 02116

Theodora T. Tilton
8010 Hamilton Lane
Alexandria, VA 22308

Ron Tirpak
10541B Lakeside Drive S.
Garden Grove, CA 92640

Greg Tisdale
35 Briarwood Place
Grosse Point Farms, MI
48236

Linda Tompkin
4780 Medina Road
Copley, OH 44321-1141

Lois Salmon Toole
561 North Street
Chagrin Falls, OH 44022

Nedra Tornay
2131 Salt Air Drive
Santa Ana, CA 92705

Sharon Towle
2417 John Street
Manhattan Bch, CA 90266

Thomas V. Trausch
2403 Mustang Trail
Woodstock, IL 60098

Susan Webb Tregay
470 Berryman Drive
Snyder, NY 14226

Doris O. Turnbaugh
6340 S.e. Ames Way
Hobe Sound, FL 33455

Linda J. Chapman Turner
Route 2 Box J
Jane Lew, WV 26378

Mary Unterbrink
3998 N.W. 7th Place
Deerfield Beach, FL 33442

James D. Vance
Route 1, Box 165A
Carmel, CA 93923-9803

Diane Van Noord
5072 N. Lakeshore Drive
Holland, MI 49424

Ted Vaught
1527 N.E. Hancock Street
Portland, OR 97212

Janet B. Walsh
130 W. 80 2R
New York, NY 10024

Jean Warren
22541 Old Santa Cruz
Highway
Los Gatos, CA 95030

Ben Watson III
3506 Brook Glen
Garland, TX 75044

Kitty Waybright
1390 Baily Road
Cuyahuga Falls, OH 44221

Michael J. Weber
12780 59th Street N.
Royal Palm Beach, FL
33411

Larry Webster
116 Perkins Row
Topsfield, MA 01983

Murray Wentworth
132 Central Street
Norwell, MA 02061

Dee Wescott
165 Devonshire
Branson, MO 65616

E. Gordon West
2638 Waterford
San Antonio, TX 78217

Arne Westerman
711 SW Alder #313
Portland, OR 97205

Eileen Monaghan Whitaker
1579 Alta La Jolla Drive
La Jolla, CA 92037

Eric Wiegardt
Box 1114
Ocean Park, WA 98640

Marjean Willett
4141 N. Henderson Road
#701
Arlington, VA 22203

Joyce Williams
Box 192
Tenants Harbor, ME 04860

Cynthia L. Wilson
2 Side Hill Road
Westport, CT 06880

Sharon Wooding
Box 992 Lawrence
Academy
Groton, MA 01450

Eudoxia Woodward
24 Kenmore Road
Belmont, MA 02178

Patricia Wygant
10 Winhurst Drive
Rochester, NY 14618

Ruth Wynn
30 Oakledge Road
Waltham, MA 02154

Marvin Yates
1457 Highway 304
Hernando, MS 38632

Yee Wah Jung
5468 Bloch Street
San Diego, CA 92122

Maxine Yost
915 West B
North Platte, NE 69101

Zheng-ping Chen
8139 S. Wood Drive #102A
Garrettsville, OH 44231